HOLBEIN

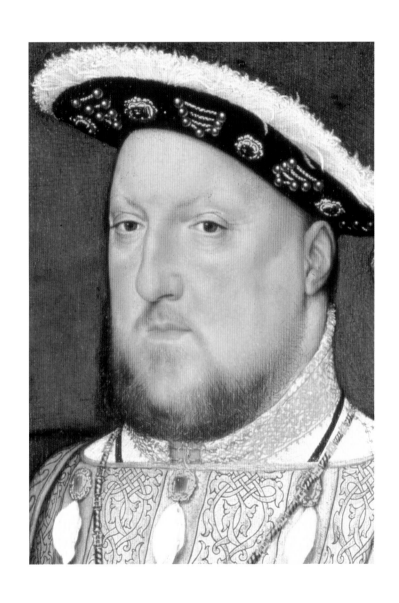

PUBLISHED BY CHAUCER PRESS
20 BLOOMSBURY STREET, LONDON WC1B 3JH

© CHAUCER PRESS, 2005

ISBN 1 904449 328

A COPY OF THE CIP DATA IS AVAILABLE FROM THE
BRITISH LIBRARY UPON REQUEST

DESIGNED BY POINTING DESIGN CONSULTANCY

TYPSET BY ROWLAND TYPESETTING

THIS BOOK, EDITED BY CHRISTOPHER WRIGHT,
IS A REVISED AND UPDATED VERSION OF AN EDITION FIRST PUBLISHED IN 1979

IMAGE ACKNOWLEDGMENTS:
BRIDGEMAN ART LIBRARY
AKG LONDON,
REMIGIUS VAN LEEMPUT (D. 1675) COPY OF HOLBEIN'S MURAL, HAMPTON COURT PALACE, JOHANNES FROBEN,
NOLI ME TANGERE, SIR THOMAS MORE, SIR JOHN MORE, ANNE CRESACRE, WILLIAM WARHAM, JOHN GODSALVE, JOHN FISHER,
THOMAS BOLEYN, HANS OF ANTWERP, DERRICH BORN, SIR HENRY GUILDFORD, THOMAS HOWARD THIRD DUKE OF NORFOLK, UNKNOWN MAN,
SOLOMON AND THE QUEEN OF SHEBA, HENRY BRANDON, SECOND DUKE OF SUFFOLK, CHARLES BRANDON, THIRD DUKE OF SUFFOLK, LADY AUDLEY,
A LADY CALLED 'CATHERINE HOWARD' © ROYAL COLLECTION 2004.

PRINTED IN CHINA BY SUN FUNG OFFSET BINDING CO. LTD.

HOLBEIN

JANE ROBERTS

CHAUCER PRESS
LONDON

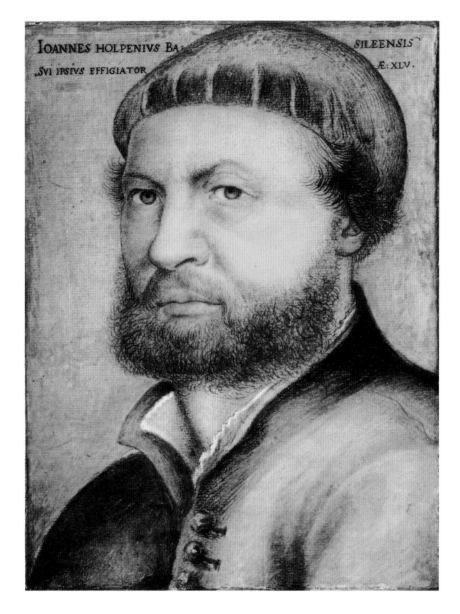

Self-portrait
FLORENCE, Galleria degli Uffizi. 1543.
Black and coloured chalks on pink prepared paper,
extensively worked over in watercolour and gold paint.
Inscribed: IOANNES HOLPENIVS
BASILEENSIS SVI IPSIVS EFFIGIATOR AE.
XLV.

The status of this drawing is problematical, for it has
been extensively worked over by later hands. The
features of the artist are the same as those seen in the
miniature self-portrait of the same date (Plate 91), but
while Holbein's hair is shown in the drawing it is
covered with a hat in the miniatures. The inscription is
not original but apparently follows the wording of an
old one which is still partly visible. It is possible that in
its original state this drawing was used as a preparatory
study for the miniatures: the technique is, in any case,
very similar to that of Holbein's drawings of the
second English period. Much of the overpainting was
apparently carried out at the start of the eighteenth
century when the drawing was incorporated in the
collection of artists' self-portraits formed by Cardinal
Leopoldo de' Medici; at the same time it was enlarged
on all four sides.

HANS HOLBEIN THE YOUNGER

HANS HOLBEIN'S BIOGRAPHERS are confronted with a number of problems. There is a tantalizing scarcity of documentary evidence concerning the artist's life, and while there is a superabundance of works, in particular portraits, to fit into his life history, many of his most important works are known through written descriptions, preparatory studies and copies alone. This is true both of his early works, including all the house façades, and some of the later ones such as *The More Family Group* (Plate 31) and the Whitehall mural (fig. 9). In addition, Holbein reached stylistic maturity early and died, in his mid-forties, without crucially altering his style for at least the last fifteen years of his life, so that it is often difficult to place his undated works.

The barest skeleton of his biography is well known. He was born in Augsburg in 1497/98, the second son of the painter Hans Holbein who gave him his earliest training. The eldest son of the family, Ambrosius, was also an artist and for a time the two brothers shared a studio. They are seen together with their father as onlookers in a panel from the elder Hans's *Baptism of St Paul* (fig. 1). By 1515 the two younger Holbeins had moved from their native town and country and settled in Basel, where Hans was principally based until 1526. The brothers visited Lucerne in 1517 and 1519, and from there they most probably travelled to Italy. Hans the younger became a member of the painters' guild in Basel in 1519 and in the same year took over his brother's studio; after this date nothing further is heard of Ambrosius so we must presume that he died around this time. In the following year, 1520, Hans was elected chamber master of his guild and became a citizen of Basel. Also about this time he married Elsbeth Schmid, a tanner's widow with one son; in the ensuing years the couple produced two boys, both of whom became goldsmiths, and two girls, and while Holbein journeyed to Antwerp and

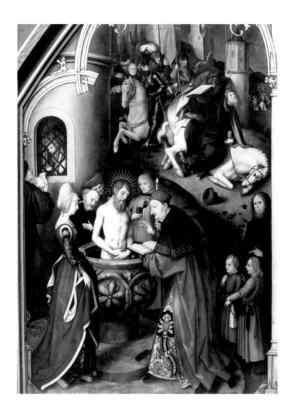

fig. 1
Hans HOLBEIN the elder (c.1465–1524)
The Baptism of St Paul
AUGSBURG, Städtische Kunstsammlungen.
c.1503–04. Oil on panel 187·8 x 90·7 cm.

This painting occupies part of the central panel of the altarpiece entitled *The Basilica of St Paul*, painted c.1503–04 by the elder Holbein for the Convent of St Catherine in Augsburg. Among the onlookers at the baptismal ceremony are the two Holbein sons, Ambrosius and Hans, with their father. The two boys were also depicted together by their father on a sheet of metalpoint studies dated 1511 in Berlin (Staatliche Museen, Kupferstichkabinett).

to England his family appears to have lived permanently in Basel. Meanwhile Hans Holbein the elder continued to paint until the time of his death in 1524, finding work throughout the larger towns of southern Germany. He apparently left a quantity of valuable painting materials at Isenheim, which his second son attempted, unsuccessfully, to retrieve on numerous occasions after his father's death.

There are dated works by the younger Holbeins throughout their residence in Basel, including panel paintings, mural decorations and designs for book illustrations. In 1523–24 Hans travelled through France and the Netherlands (see Plates 29 and 30), and two years later he left Basel for the first of his two visits to England. The reason for this visit is suggested in a passage concerning the artist in a letter of 29 August 1526 addressed by Erasmus, another resident of Basel, to his fellow-scholar Aegidius in Antwerp: 'Hic frigent artes, petit Angliam ut

corrodat aliquot Angelatos.' ('Here the arts are freezing, [so Holbein] is on his way to England to pick up some angels [coins] there.') Carrying this letter and the introduction it contained Holbein visited Aegidius in Antwerp on his way to England. He had reached London by December 1526 and remained there until the summer of 1528. During this first visit he must principally have been occupied in painting *The More Family Group* (Plate 31) and other miscellaneous portrait commissions. There is no certain evidence that he had any direct contact with the royal court at this time, and in 1528 he returned to Basel, where he bought a large house overlooking the Rhine; in 1531 he acquired the adjoining house as well. However, by the early 1530s, the religious and political climate in Basel was, if anything, even less encouraging for artists than it had been in 1526 and Holbein therefore set out for England for a second time, once again stopping at Antwerp on the way. By July 1532 he had arrived in London and dated works punctuate his residence there until his sudden death of the plague in 1543. In 1538 and 1539 he was travelling on the continent with the principal object of recording the likenesses of prospective brides for King Henry VIII, and for a short period at this time he visited Basel, where his family was still residing. There a banquet was held in his honour and the City Council offered him a pension and privileges to try to tempt him to remain permanently, but Holbein must by then have had too many commitments in London to make such a project possible. From 1536 at least, he had been working for the King and his private portait-painting practice in London was evidently thriving. In addition, he was apparently very happy there.

At the time of his death Holbein was a resident of the parish of St Andrew Undershaft in the City of London, and yet his will makes no mention of any property owned by him there, beyond such immediate possessions as a horse and some clothing. He was never a naturalized Englishman and his family continued to reside in his substantial house in Basel, latterly thriving on the proceeds of the will of a rich uncle and the pension granted to Holbein by the City Council, notwithstanding his failure to return home permanently. In London he left

several debts and 'two chylder wich be at nurse', who were evidently illegitimate and who were to be provided for out of the proceeds from the sale of his possessions. Neither his will nor any contemporary document makes any mention of the studio at Whitehall with which Holbein is always said to have been provided by the King, but in view of his extensive work for the court it is far more likely that his studio was there than that it was adjacent to or part of his house in the east of London.

We know almost nothing about Holbein's character, although we may perhaps try to guess at it from one of his self-portraits (frontispiece and Plate 91), three of which are dated 1543, the year of his death. Although his facial features do not suggest a fiery disposition there is a story concerning his quick temper which has been repeated often since it was first reported in print by the Flemish painter Karel van Mander in *Het Leven der Doorluchtighe Nederlandtsche en Hoogduytsche Schilders* of 1618. According to van Mander, when the artist was painting the portrait of a certain lady for the King he received an unannounced visit from a nobleman, and dismissed his visitor by hurling him downstairs, before rushing to the King to apologize.

From the evidence contained in Holbein's surviving and recorded works we can form some idea of the social circles in which the artist moved. Through his activity in designing title-pages and book illustrations during his years in Basel he met the printer Froben (Plate 12) and the scholar Amerbach (Plate 19) and thus became acquainted with other humanists residing in that town and, in particular, with Erasmus (Plates 26, 28 and 111), who, at that time, was employed by Froben; around 1530 Holbein also painted the portrait of *Melanchthon* (Plate 50), another member of this circle. Several of Thomas More's writings were published in Basel and were illustrated with designs (Plate 101) provided by either Hans or Ambrosius Holbein, but it seems that Hans Holbein and Thomas More did not meet until the artist first travelled to England. They must have struck up a close friendship, and it is probable that Holbein was resident in More's house at Chelsea for much of this first stay in England. It appears then that Holbein

portrayed these humanists out of friendship and not merely as their paid portrait painter; Erasmus was certainly an important source of encouragement and influence for the artist's career. Soon after Holbein's first arrival in England More wrote in a letter to Erasmus dated 18 December 1526: 'Your painter, dearest Erasmus, is a wonderful artist, but I fear he is not likely to find England so abundantly fertile as he had hoped; although I will do what I can to prevent his finding it quite barren.' Another scholar with whom Holbein appears to have contracted a close friendship was the French poet Nicolas Bourbon, for after Bourbon's return to France from England in 1535 he included the artist among a list of those 'with whom you know me connected by intercourse and friendship', to be greeted 'in my name as heartily as you can'. But in general we know little about the circles in which Holbein moved during his second stay in England. In the year of the artist's return, 1532, More resigned from office and Archbishop Warham (Plate 37), with whom Holbein had also been in contact earlier, died. Holbein, therefore, had to find new friends and patrons, and he appears to have turned to the community of Hanseatic merchants resident in the German Steelyard in the City of London. The first record of his return to London is, indeed, apparently contained in the date, 26 July 1532, on the portrait of a member of the German community, generally thought to be the goldsmith Hans of Antwerp (Plate 54). In any case, Hans of Antwerp must be listed among Holbein's friends, for he witnessed the artist's will and acted as one of his executors; his co-witnesses were other, lesser-known, members of the English artistic community with whom Holbein presumably passed much of his time.

Through his employment at the English court Holbein must have come to know most of the people of power and importance in the land. Owing to the fact that the relevant accounts for the years 1533 to 1537 are missing we do not know exactly when the artist entered royal employ, although from 1538 at least he was receiving an annual salary of £30 from the crown. In Bourbon's letter of 1536 Holbein is referred to as 'the royal painter', and it is possible that by

this date he had been working for Henry VIII for at least a year as Thomas Cromwell, the King's Secretary, was portrayed by him in 1534 (Plate 65). Holbein was certainly well known to one of the royal servants, Sir Philip Hoby, for they travelled to Brussels together in 1538 to visit Christina of Denmark on the King's behalf. And the German, Nicolaus Kratzer, a royal astronomer, whom Holbein had portrayed in 1528 (Plate 44), employed the artist to carry Protestant books to Cromwell in 1536. It should be noted here that during his stay in Basel from 1528 to 1532 Holbein had affirmed his allegiance to the reformed religion and could therefore settle happily in England during the troubled years leading up to More's execution. His personal connection with the crown can only be guessed at on the basis of such paltry evidence as the fact that he was frequently paid his salary in advance and that, on New Year's Day 1540, Holbein presented the King with a portrait of Prince Edward, usually identified with the one now in Washington (Plate 78), while the painter was presented by the King with a gold cup on the same occasion.

Holbein's training in his father's studio in Augsburg provided him with a solid grounding in the techniques of oil painting, draughtsmanship and designing for books and the decorative arts as practised in Germany in the last years of the fifteenth century. Augsburg was probably the first south German town to feel the effects of the Italian Renaissance, for it stood on one of the main routes out of Italy to the north and was consequently a thriving commercial and intellectual centre. A work such as *The Baptism of St Paul* of c.1503–04 (fig. 1) by the elder Holbein reveals details of Italian influence only in a very limited way: both the composition and the perspective are disunited while the fall of drapery and the proportions of the figures are more typical of late mediaeval than of Renaissance art. Compared to this work the younger Holbein's *Flagellation of Christ* (Plate 2), painted approximately ten years later, and the *Christ in the Tomb* of 1521 (Plate 11) have a power and expressiveness worthy of Grünewald, achieved through an economy of gesture and setting which can be found throughout Holbein's *oeuvre*.

What is probably Holbein's earliest dated work is the table-top which was painted to celebrate the marriage of Hans Baer in June 1515 and which is, therefore, the first evidence of the artist's presence in Basel (Plate 1). This curious object shows a wide variety of animals, birds and instruments, depicted as a rather crude *trompe-l'oeil* and surrounded by country scenes of revelry and jousting. Similar characteristically German types reappear in Holbein's design for the Haus zum Tanz (Plate 6) of about five years later and also in several of his woodcut designs of the 1520s. Other early works reveal more typically Italian features, such as the *all'antica* detail in the backgrounds of the 1516 portraits of Jakob Meyer and his wife (Plates 3 and 4) and in the decoration for Jakob von Hertenstein's house of 1517–19 (Plate 10), while Holbein's skill in pure penmanship can be seen in the marginal notes he added to a copy of the 1515–16 edition of Erasmus's *Encomium Moriae* (Plate 9). If the date of Holbein's birth, derived from an inscription on a portrait drawing by the elder Holbein of his two sons, is correct then he would have been only eighteen or nineteen years of age when this group of works was executed.

Holbein's talents as a decorator were soon put to great purpose on the façades of houses in both Lucerne and Basel. Much of his time during his periods of residence in Lucerne must have been spent in adorning both the interior and exterior of the new house of Jakob von Hertenstein, chief magistrate of Lucerne, on which building work had ceased only in 1517, the year of Holbein's first visit to the town. The house was demolished in 1825 but some of Holbein's designs survive (Plates 7 and 10), and we can reconstruct the appearance of the whole from the evidence provided by these drawings and by various written descriptions. In Basel Holbein decorated several houses, of which the best-known is probably the Haus zum Tanz of c.1520–22 (fig. 2 and Plates 5 and 6), belonging to the wealthy goldsmith Balthasar Angelrot. Once again the house has been demolished but its original appearance is known from drawings and written descriptions. In both cases, but especially in that of the Haus zum Tanz, there was a wealth of *all'antica* detail and sophisticated illusionism which must surely have derived from a

fig. 2
H. E. von BERLEPSCH
Reconstruction of the Haus zum Tanz Façade
BASEL, Offentliche Kunstsammlung,
Kupferstichkabinett. 1878.
Watercolour 62 x 91·5 cm.

This reconstruction was made on the basis of
written descriptions and earlier views of the house at
a time when it was still standing; the Haus zum Tanz
was demolished in 1907. Holbein's work on the
house, which belonged to the goldsmith Balthasar
Angelrot, can be dated c.1520–22. It was his most
daring venture in the exploitation of *trompe-l'oeil*
techniques combined with detail which mostly
derived from Italian sources (see Plates 5 and 6).

firsthand knowledge of works by Mantegna (fig. 3) and of the highly decorated polychrome exteriors of contemporary north Italian churches such as the Certosa at Pavia. In his designs for the Haus zum Tanz Holbein apparently had to accommodate existing window and door openings spaced at irregular intervals, and to overcome this he cloaked the whole in a web of painted architecture with a sophistication far in advance of other northern decorative schemes. This fictive architecture was inhabited by a curious, and typically German, mixture of dancing peasants, weird animals and scenes from ancient history, including a great horseman apparently leaping from the façade at second-floor level, a conceit taken from a description by Livy. It is hard, if not impossible, to imagine the effect created by Holbein's paintings on the Haus zum Tanz. The house stood at the corner of two narrow streets so that the decoration could never have been seen easily from ground level; the main façade was on the shorter of the two sides. Nevertheless it was a *tour de force* for an artist still in his early twenties and must have established further his reputation in Basel.

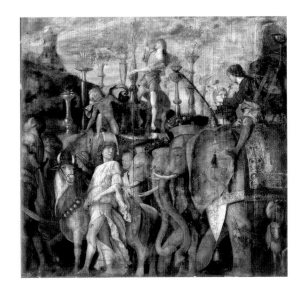

fig. 3
Andrea MANTEGNA (c.1431–1506)
The Triumph of Caesar, canvas five: *Sacrificial Bull and Elephants*
HAMPTON COURT PALACE, Royal Collection.
Tempera on canvas c.274 x 274 cm.

This canvas is one of a group of nine *Triumphs* painted by Mantegna in the 1480s for the Palazzo Ducale at Mantua. The series soon became well-known through the publication of engravings recording each scene, and pictorial quotations from it appeared in paintings and sculpture throughout Europe during the following decades. The triumphal procession in the upper frieze of Holbein's façade of the von Hertenstein house in Lucerne (see Plate 10) was clearly connected with this series, as were his two *Triumphs* for the German Steelyard (see fig. 5 and Plate 67), painted around fifteen years later.

At the same time as Holbein was at work on the Haus zum Tanz, he also began a large decorative scheme intended to cover the walls in the Great Council Chamber of Basel Town Hall, which was rebuilt from 1508 to 1521. Fragments of his work, carried out in two periods, from 1521 to 1522 and c.1530, still survive (Plate 52), as do the artist's studies for the individual scenes (Plates 8, 51 and 53). Once again there is a strong Italian flavour to this series of scenes from ancient and biblical history, intended to inspire the councillors in their discussions. The painted architectural framework in which the separate episodes were set reminds one immediately of the religious and secular cycles of the Italian Renaissance (fig. 4) and in particular of those in the Palazzo Ducale and the various *scuole* in Venice.

The Triumph of Riches and *The Triumph of Poverty* which the artist painted for the Guildhall of the German Steelyard in London c.1532–33 belong to a scheme of a similar nature to that of the Basel murals and are also known only through copies (fig. 5) and preliminary designs (Plate 62).

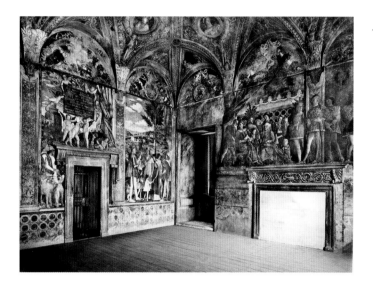

fig. 4
General view of the Camera degli Sposi
showing the west and north walls.
MANTUA, Palazzo Ducale.

The frescoes painted by Mantegna in the
Camera degli Sposi in the early 1470s
contain numerous features which could
possibly have served as models for
Holbein's paintings on house façades and
for his wall decorations in Basel Town
Hall. Both the *all'antica* detail and the
trompe-l'oeil effects of figures painted so as
to appear to walk in front of or behind
the painted architecture are prototypes of
decorative schemes both in Italy and in
the north of Europe. In addition, the
court scene on the north wall, depicting
members of the ruling Gonzaga dynasty,
may be seen as a precedent for Holbein's
More Family Group (see Plate 31).

Both their medium, tempera on canvas, and their content recall Mantegna's *Triumph of Caesar*
series (fig. 3) which Holbein might have seen in Mantua during his supposed Italian visit,
although he would probably have known the compositions well at second hand through
engravings. At this point it is perhaps justifiable to consider the tiny composition of *Solomon and
the Queen of Sheba* (Plate 85), for although the purpose of this painting is not known it shares
various features with the large-scale decorative works and is comparable in many ways to the
composition of *Rehoboam Rebuking the Elders* from the Basel Great Council Chamber (Plate 51).
The miniature painting is highly finished, and there are some exquisite passages, particularly in
the female figures at bottom left. Even bearing in mind the different contexts, scale and degrees
of finish of this painting and the preparatory studies for the two *Triumphs*, it is hard to believe
that stylistically *Solomon and the Queen of Sheba* follows rather than precedes them, as has always
been argued. In the absence of evidence to the contrary it should surely be dated right at the
beginning of Holbein's second English period, c.1532.

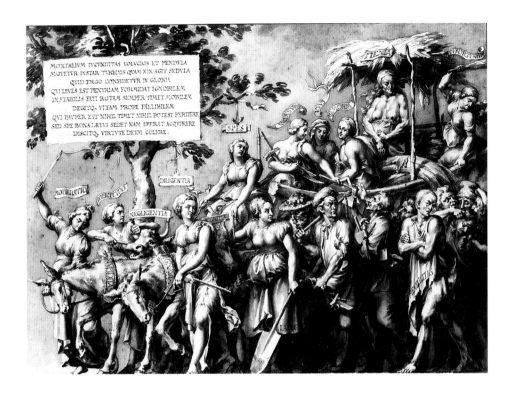

fig. 5
Jan de BISSCHOP (1628–71)
Copy of Holbein's 'The Triumph of Poverty'
LONDON, British Museum, Department of Prints
and Drawings.
Pen and wash over black chalk
34·5 x 47·4 cm.

This drawing provides evidence of the appearance of
one of the two *Triumphs* which Holbein executed for
the Guildhall of the German Steelyard c.1532–33 (see
Plate 62). The original compositions contained life-size
figures and were painted on canvas; they rapidly
became known throughout Europe, as is clear from
the large number of surviving copies, and greatly
enhanced Holbein's reputation. The pictures remained
in the precincts of the Steelyard until 1598, when it
was closed by Elizabeth I. Soon after they were
presented to Henry, Prince of Wales, and were later in
the collection of Thomas Howard, second Earl of

Arundel. The last record of their existence is in 1666,
when they belonged to the offices of the Hanseatic
League in Paris, having been brought there from
Flanders. It is probable that de Bisschop's copies of
the two paintings were made in Amsterdam. In *The
Triumph of Poverty* the aged and decrepit figure of
Poverty sits on a wagon driven by Spes and drawn by
two oxen called Negligentia and Pigritia and two asses
called Stupiditas and Ignavia. These animals are led by
four women, Moderatio, Diligentia, Solicitudo and
Labor. Behind the wagon there are other figures such
as Infortunium, Mendicitas and Miseria. The lesson to
be learnt by the merchants from this composition was
the virtue to be found in honest poverty. The
programme for both pieces has been attributed to Sir
Thomas More, and if this were so it would provide a
unique piece of evidence of Holbein's continued
contact during his second visit to England with the
principal patron of his first visit.

The problematic dating of the *Solomon* miniature is symptomatic of Holbein's *oeuvre*, for apart from his very earliest works he progressed without any very clear stylistic development. Although there certainly appears to be a new sense of polish to the works of his second English period, we do not know how such works compared with the final appearance of *The More Family Group*, for instance, one of the outstanding achievements of his first English period. The problem is complicated by the fact that a large proportion of Holbein's work during the first part of his career has not survived. In Basel his main activity was the production of religious paintings, especially altarpieces, for the main churches of the town. These were nearly all destroyed during the waves of purging and persecution that swept through Switzerland during the Reformation of the 1520s and 1530s, and the fact that any religious works survive at all in Basel is chiefly due to the collecting activities of the artist's friend and patron, Bonifacius Amerbach (Plate 19), who formed the greater part of the collection of works by Holbein now preserved in the Offentliche Kunstsammlung in Basel. Amerbach collected chiefly small-scale religious works, and the altarpieces were in the main destroyed entirely. Among the few surviving large-scale religious compositions are the two altarpieces of the 1520s, *The Solothurn Madonna* of 1522 (Plate 13) and *The Meyer Madonna* of c.1528 (Plate 45). In *The Solothurn Madonna* the Virgin and Child are seated between St Nicholas and St Ursus under a bare tunnel-vault, while in *The Meyer Madonna* they stand before a niche and in front of them there is a curious group containing the patron, Jakob Meyer, and his two wives, two sons and one daughter. Meyer's first wife had died in 1511 and his two sons both died in 1526. X-rays have revealed that the portrait of the first wife was added at the back, while those of the second wife (see also Plate 4) and of the daughter were altered, and it is possible that when Holbein left Basel in 1526 the painting was unfinished, and that he completed it, with alterations, after his return two years later. These altarpieces employ different Italian compositional types: in *The Solothurn Madonna* the *sacra conversazione*, in *The Meyer Madonna* the *Madonna della Misericordia*, both in distinctive

quasi-Italian forms with semi-circular arches crowning the centre of each panel. We may presume that, following their Italian prototypes, the architecture within the paintings would have been complemented by that of the frame, particularly of *The Solothurn Madonna*. In both cases there is an important deviation from the Italian models in placing all the figures in the foreground rather than ranging them in depth, but in general these paintings, as with the decorative murals, are remarkably Italianate. We can even find Italian sources for the actual poses of the figures: the brilliant foreshortening of the Christ Child's outstretched arm must surely owe something to the similar gesture of the Virgin in Leonardo's *Virgin of the Rocks* (fig. 6), and the static grouping of the saints and Madonna and Child of *The Solothurn Madonna* must similarly have been modelled on north Italian altarpieces. Another religious work from this decade is the *Noli Me Tangere* in the Royal Collection (Plate 20). In certain respects this panel appears old-fashioned when compared to the two altarpieces, and it certainly retains the power and Grünewald-like character of the early *Flagellation* (Plate 2) and *Christ in the Tomb* (Plate 11). But in other ways *Noli Me Tangere* is a more accomplished work. Sixteenth-century iconoclasts have deprived us of strictly comparable material, and this panel is therefore alone in Holbein's work in even attempting to portray a figure subject in a landscape setting. The colour throughout, and in particular of the scene within the rock, is of comparable intensity to that in the eight scenes of *The Passion Altarpiece* in Basel (Plates 21–23), which must also date from c.1524.

Holbein's stylistic development, such as it was, can most easily be traced through a study of his portraits, many of which are dated. Owing largely to historical accident and to the fact that there was little if any demand for religious art in Protestant England where Holbein spent almost half of his active life, he came to be known primarily as a portraitist even during his own lifetime. In the course of the correspondence concerning the portrait of *Christina of Denmark, Duchess of Milan* (Plate 68) the English ambassador in Brussels mentioned that Henry VIII

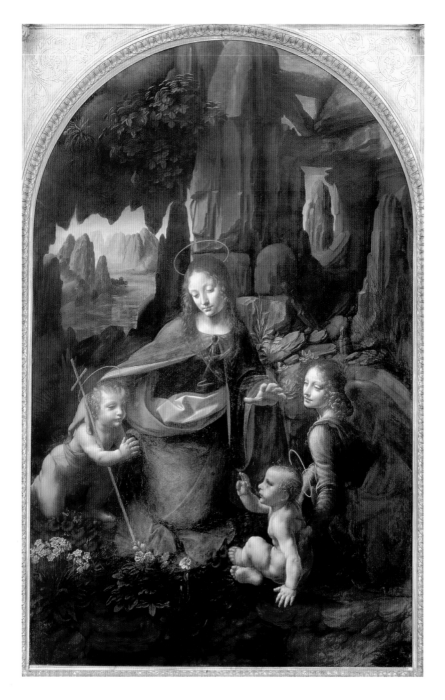

fig. 6
LEONARDO da Vinci (1452–1519)
The Virgin of the Rocks
LONDON, National Gallery.
Oil on panel 189·5 x 120 cm.

This altarpiece, which was commissioned from Leonardo in 1483 for the Church of San Francesco Grande in Milan, was well known and often copied during the sixteenth century. It is possible that the gesture and foreshortening of the Virgin's hand inspired the very similar gesture of the Christ Child in Holbein's *Meyer Madonna* (Plate 45). This connection, coupled with the numerous other Italianate features found in Holbein's work, suggests that he travelled to north Italy early in his career.

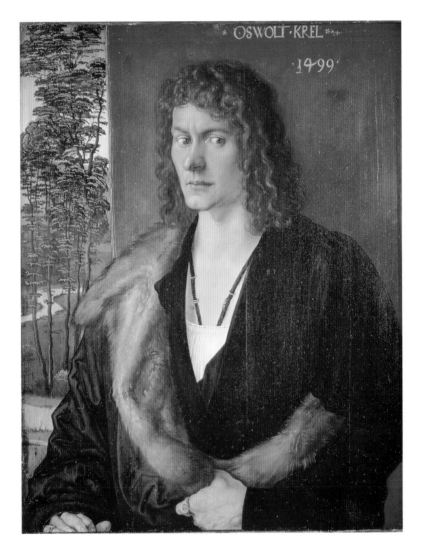

fig. 7
Albrecht DÜRER (1471–1528)
Oswald Krel
MUNICH, Alte Pinakothek. 1499.
Oil on panel 49·6 x 39 cm.

This portrait, one of Dürer's finest, is an example of the kind of picture which must surely have determined the formation of Holbein's portrait style. The particular type to which it belongs follows that developed in the Netherlands and much used in Italy around the end of the fifteenth and beginning of the sixteenth centuries, with an area of landscape shown to the right or left and the sitter depicted at half-length with his hand resting on a ledge running parallel to the picture plane in the foreground. Holbein apparently never included a full landscape background in his portraits, although there is the suggestion of an alpine landscape in the portrait of *Bonifacius Amerbach* (Plate 19). Otherwise the pose of Holbein's sitters is very similar to that of Dürer's *Oswald Krel*, for instance his depictions of *Jakob Meyer* and *Dorothea Kannengiesser* (Plates 3 and 4), *Sir Thomas More* (Plate 33) and *Derich Born* (Plate 58). Holbein may in addition have derived his skill in the depiction of textures, and in particular fur, from the older artist.

esteemed Holbein chiefly as 'very excellent in making Physiognomies'. The companion portrait of *Jakob Meyer* and *Dorothea Kannengiesser* of 1516 (Plates 3 and 4) are the earliest dated works in this genre. Meyer was elected Burgomaster of Basel in the year in which his portrait was painted and was the first commoner to hold this office; he must have been well-known to Holbein for in the previous year the artist had painted the Baer table-top (Plate 1) to commemorate the wedding of the brother of Meyer's first wife, Magdalena Baer, and about ten years later Meyer commissioned an altarpiece from the artist for the chapel of his castle near Basel (Plate 45). The portraits of 1516, for which there are preparatory silverpoint studies in Basel, employ the sophisticated device of placing both Meyer and his second wife within the same arched loggia in which they are also linked by their glances, although the panels on which they are painted are quite separate. As in the case of *The Solothurn Madonna* and *The Meyer Madonna*, the spatial unity of the portrait pair would presumably originally have been strengthened by details of the framing. Another early portrait is that of Holbein's friend and benefactor, *Bonifacius Amerbach*, dated 1519 (Plate 19) which reveals the direct influence of the art of Albrecht Dürer both in the skilful concentration on facial features and in the handling of the paint, as in, for example, the older artist's portrait of *Oswald Krel* of 1499 (fig. 7). Holbein was over a generation younger than Dürer, but in many ways their careers can be considered in parallel: although Dürer was based principally in his home town of Nuremberg, he paid frequent visits to Augsburg and Basel and also to Antwerp, and his style was greatly affected by his direct contact with contemporary Italian art. In addition, both Dürer and Holbein were close to Erasmus, who described Dürer in a letter of 1525 as 'an artist of the first rank', although three years later he wrote: 'Dürer painted my portrait, but it was nothing like.' Erasmus apparent sat to Dürer in Antwerp in 1520 in the presence of Nicolaus Kratzer (Plate 44); Dürer's engraved portait of *Erasmus* of 1526 was probably made on the basis of a sketch executed at this sitting.

Seven years after the portrait of *Amerbach*, Holbein painted the curious pair of panels, *Laïs*

Corinthiaca (Plate 42) and *Venus and Amor* (Basel, Offentliche Kunstsammlung). When these paintings were in the Amerbach collection they were said to represent the artist's mistress, Magdalena Offenburg; her depiction as Laïs of Corinth, the mistress of Apelles, was therefore clearly appropriate. Both panels were at one time attributed, significantly, to the Lombard artist Cesare da Sesto, who died in Milan in 1523, and their connection with Italian sources is plain. The gesture of both *Laïs* and *Venus*, with their right hands outstretched, is close to that of Christ in Leonardo's mural of *The Last Supper* in the Church of Santa Maria delle Grazie, Milan; in addition, the use of *sfumato* modelling, which can be seen as early as the *Amerbach* portrait (Plate 19), is yet more pronounced in these panels. Numerous Italian characteristics in *The Meyer Madonna*, painted in the same year and apparently also employing Magdalena Offenburg as the model for the Madonna, have already been noted; in addition, the extraordinarily soft modelling of the Christ Child and the head of the Virgin in this altarpiece, and in the pair of female half-lengths, might be used as evidence that Holbein revisited Italy shortly before his first departure for England in 1526. This use of *sfumato* modelling is contemporaneously proved by the very beautiful sheet of studies in the Louvre (Plate 27), which contains a drawing of Erasmus's right hand as depicted in the Louvre painting and of the left as shown in the picture dated by Holbein (Plate 26). A third portrait of the scholar, painted at around the same time, was taken by Holbein to Amerbach in Montpellier in 1524. This portrait is probably identifiable with the painting now seen again from time to time in Holbein's portraits and perhaps most notably in that of *Derich Born* of 1533 (Plate 58). But the dangers of employing the normal stylistic criteria to place undated works in Holbein's *oeuvre* are once again clearly appreciated when we note that the portrait of *Georg Gisze*, dated 1532 (Plate 55) makes little if any use of such modelling. The problem is certainly aggravated by the uneven condition of many of Holbein's paintings, in some of which the surfaces are obscured by layers of varnish, while in others layers of Holbein's own varnish have been inadvertently removed. It may be no accident, however, that in the royal portraits of the later 1530s (Plates 76, 82 and 83) the facial

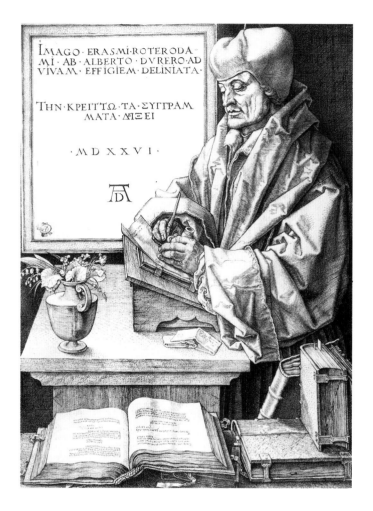

fig. 8
Albrecht DÜRER (1471–1528)
Desiderius Erasmus
LONDON, British Museum, Department
of Prints and Drawings. 1526.
Engraving 24·9 x 19·3 cm.

Dürer's engraved portrait of *Erasmus* provides yet another example of a likeness of the scholar, who appears to have taken a particular interest in his own portraiture. This plate was made three years after the main group of portraits of Erasmus by Holbein (Plates 26 and 28) but probably on the basis of a sitting in Antwerp in 1520. In a letter of 1528 Erasmus wrote: 'Pinxit me Durerius, sed nihil simile' (Dürer painted my portrait, but it was nothing like), and indeed were it not for the similarities of pose and accompanying detail it would be hard to believe that the man depicted here was the same as that shown by Holbein.

features of the sitters are depicted with the most limited use of modelling by softening shadow. Having made this observation one is tempted to go further and to suggest that Queen Elizabeth I's well-known dislike of deep shading in any portrait likeness may have been inherited from her father.

Holbein's reputation as a portraitist appears to have been made to a large extent by his series of portraits of Desiderius Erasmus painted in 1523. The scholar had a great interest in supervising the painting, or drawing, of his own likeness, which survives from the hands of

various artists (see fig. 8). When Erasmus wrote introducing Holbein to Aegidius in Antwerp, he suggested that the painter might visit Quentin Metsys, who had executed a diptych containing portraits of Aegidius and Erasmus as a gift from the sitters to More in 1517 and who also designed a medal bearing the likeness of Erasmus's head in 1519. In June 1524 Erasmus wrote to his, and Dürer's, friend Willibald Pirkheimer at Nuremberg: 'Only recently I have again sent two portraits of me to England, painted by a not unskilful artist. He has also taken a portrait of me to France.' That Holbein was the artist responsible for these pictures is proved by a passage in a book published by Froben in March 1526. This mentions Holbein, who 'last year painted, most successfully and finely, two portraits of our Erasmus of Rotterdam, which he afterwards sent into England'. Other documents prove that Warham was the recipient of one of the two portraits sent to England. The painting in the Louvre (Plate 28), datable to 1523 on the basis of the writing on which Erasmus is engaged, is usually considered to be one of these, while the other, dated 1523, is identified as the panel which is now in a private collection (Plate 26). These portraits show the scholar writing and then in contemplation, in a format that is ultimately derived from paintings and engravings showing St Jerome in his study. The scholar's profile in the Louvre picture, outlined against the richly patterned curtain hanging behind him, has a sensational power which is seldom equalled in Holbein's art. When Holbein returned to the continent in 1530 he again painted Erasmus, by that time resident in Freiburg. There are several undistinguished variants of the privately owned panel which appear to date from around this time and also the tiny roundel in Basel which was painted as a companion to that of *Froben*, now in the Merton collection. The last of Holbein's portraits of Erasmus was a woodcut published in 1535, the year before the scholar's death (Plate 111). It shows him full-length, standing behind his personal emblem, 'Terminus', with a Latin inscription below, which reads, in translation:

Pallas, marvelling at this picture to rival Apelles, says that a library must preserve it for ever. Holbein shows his Daedalian art to the Muses, and the great Erasmus [shows] the power of his supreme intellect.

Such words of praise for the portrait painter's art were surely not empty ones in the case of Holbein's likenesses of Erasmus.

Apart from the panels discussed above, there are comparatively few dated portraits from Holbein's hand prior to his first visit to England, where he must have been chiefly employed as a portraitist. The style of the Italian Renaissance had already arrived in England by 1526, largely owing to the activities of Italian sculptors and makers of ornaments, and in particular to Pietro Torrigiano, who received the commissions to design the tombs of Lady Margaret Beaufort and of King Henry VII and his consort Elizabeth of York in 1511 and 1512 respectively. During his stay in England, which lasted spasmodically until around 1522, Torrigiano executed several portrait busts of sitters such as Henry VII and his son Henry as a young man, John Fisher and Dean Colet; a drawing by Holbein of the last survives among his portraits at Windsor. Torrigiano recruited a number of helpers during his absences from England in Italy and, together with other documented artists such as Benedetto da Rovezzano and Giovanni da Maiano, they continued to operate in England until the mid-1530s at least. So far as painting was concerned, the Renaissance style had been brought across the Channel by a handful of apparently rather second-rate artists from both Italy and the Netherlands. Antonio Toto, who was brought to England by Torrigiano, had served his apprenticeship as a painter in the studio of Ridolfo Ghirlandio in Florence; according to Vasari he was also the architect of Nonsuch, Henry VIII's great palace in Surrey, begun in 1538 and destroyed late in the seventeenth century. The names of Toto and Bartolommeo Penni, 'paynters', occur in royal household accounts from 1530; in 1538 Toto became a naturalized Englishman and five years

later he succeeded as Sergeant-Painter, a position which he held throughout Edward VI's reign. Although the careers of these two artists are fairly well known on the basis of documentary evidence, no painting can be attributed to them with certainty, and there is no record of either artist having painted portraits.

This is not the case, however, with the Flemings Lucas and Gerard Horenbout, who are recorded as having been in England shortly before Holbein's arrival. In 1534 Lucas was nominated as the king's painter, and ten years later he died in London. According to van Mander, Holbein learnt the art of miniature painting from 'Master Lukas' at the English court, and although we know nothing certain of Lucas Horenbout's *oeuvre* it seems highly probable that some of the early miniatures of Henry VIII are from his hand, and that he may have been a potential rival to Holbein as a painter of portraits. It remains a fact, however, that there are no portraits of English sitters to equal those produced by Holbein during his residence in England.

Holbein's main work during his first visit to England was the magnificent group portrait of the family of Sir Thomas More, to whom the artist had been introduced by Erasmus. As is so often the case with key works by Holbein, the original painting, which was in distemper on canvas, was destroyed in the eighteenth century having been copied several times and also recorded by the artist in a drawing sent by him to Erasmus in Basel (Plate 31). In September 1529, on receipt of this study, the scholar wrote to More's eldest daughter, Margaret (Plate 92): 'so well has Holbein depicted the whole family for me that if I had been with you I could not have seen more'. Holbein's studies for nearly all of the people included in the group survive at Windsor Castle (Plates 32–36) and are fortunately among the best-preserved of the Holbein drawings there. Such a group portrait was unique at this time both north and south of the Alps, although the scenes painted by Mantegna depicting the Gonzaga family on the walls of the Camera degli Sposi in Mantua (fig. 4) may perhaps be relevant here. And if the concept of the

entire composition was probably dependent on Italian prototypes, the poses of some of the individual figures, in particular that of More's daughter *Cecily Heron*, were close to other Italian models, for instance Leonardo's female portraits, including the *Mona Lisa* (Paris, Musée du Louvre) and *Cecilia Gallerani* (Kraków, Muzeum Narodowe). In addition to *The More Family Group*, Holbein painted a half-length portrait of More himself, dated 1527 (Plate 33). In the same year he portrayed *Sir Henry Guildford* and *Lady Guildford* (Plates 38 and 39) and *William Warham, Archbishop of Canterbury* (Plate 37) and in the following year *Sir Thomas Godsalve and his Son John* (Plate 41) and the court astronomer *Nicolaus Kratzer* (Plate 44), who was responsible for the identifying inscriptions added to *The More Family Group* drawing sent to Erasmus. There is a richness and breadth in these portraits which continues throughout Holbein's English paintings.

Apart from the likenesses of *Erasmus* and *Froben* and the very similar one of *Melanchthon* (Plate 50), very few portraits can certainly be attributed to Holbein's stay in Basel between his two English visits. Thereafter the stream of dated works recommences with the striking group of studies of merchants of the German Steelyard in London, by whom Holbein was chiefly employed in his early years after his return to England. The portraits of *Hans of Antwerp, Georg Gisze* and *A Member of the Wedigh Family* (Plates 54, 55 and 60) are all dated 1532, while those of *Hillebrandt Wedigh, Derich Tybis* and *Derich Born* (Plates 61, 56 and 57) are dated 1533, as is that of *Robert Cheseman* (Plate 64) and the magnificent double portrait of the so-called '*Ambassadors*' (Plate 59). In 1534 Holbein received an important commission to paint *Thomas Cromwell* (Plate 65), the King's Secretary, and following this he may have entered royal service. There follow the portraits of *King Henry VIII* and *Queen Jane Seymour* (Plates 82 and 83) of 1536–37, and those of the King's prospective brides *Christina of Denmark, Duchess of Milan* and *Anne of Cleves* (Plates 68 and 77) in 1538 and 1539. We know from the written accounts of the negotiations in Brussels concerning the portrait of *Christina of Denmark* that it was painted on the basis of a sitting lasting only three hours on 12 March 1538. That evening Holbein set out

on his return journey to England and on 18 March he showed the likeness of the young dowager duchess to the King in London. There was no time in between these dates for Holbein to have executed a finished oil painting of the size and quality of the picture in the National Gallery, London, and we must therefore presume that what he showed to the King was a portrait in pen and ink or coloured chalks, or even watercolour. The numerous portrait drawings at Windsor were presumably the results of sittings of similar length, an indication of Holbein's skill and facility as a portrait painter. The painting of *Christina* in London is Holbein's only surviving full-length, single-figure portrait and is a profoundly striking image. Her beauty was well-known and the King was delighted with her likeness. However, the duchess, who had close Habsburg links, would not be lured by Henry and is reported to have said 'If I had two heads one would be at the disposal of the English majesty'. In the following year Holbein was therefore again at work recording the likenesses of possible brides for the King, this time in Düren, where he portrayed the Lutheran *Anne of Cleves* and her sister the Princess Amelia, whose portrait is lost. The painting of *Anne* in the Louvre (Plate 77) is on parchment laid down to a panel and may well represent the actual likeness that Holbein took of her at this time. This portrait is less successful than that of *Christina*, which may be partly due to the different technique and also to the fact that Anne of Cleves was by all accounts no great beauty.

Another important royal commission of around the same time as the *Christina of Denmark* portrait was the Privy Chamber painting for Whitehall Palace, executed c.1536–37 and destroyed in the fire of 1698 but known from Leemput's copy (fig. 9); the cartoon for the figure of Henry VIII himself also survives (Plate 76). It is still not entirely clear where this painting was situated in the Privy Chamber, but it was definitely executed on the wall itself and would presumably have attempted to conform to the architecture of the room. The mural depicted King Henry VII and his wife Queen Elizabeth of York, with King Henry VIII and Queen Jane Seymour; the Latin inscription told of the father's victory over his foes to bring

peace to the land and the son's success in restoring religion. The figures were placed within a fictive architectural structure with a use of *all'antica* detail in the friezes and pilasters which were by now common in Holbein's work.

At the time of his death in 1543 Holbein was still working on the large composition of *King Henry VIII Granting the Charter to the Barber-Surgeon's Company* (Plate 94) which was completed posthumously by members of his studio. In this painting the King is shown to the left of centre with his own doctors Chambers and Butts by his right side and other members of the company ranged in two rather too well-ordered rows to his left. The part played by Holbein in the execution of this picture is confirmed by the X-ray of another version of the same composition held by the Royal College of Surgeons in London, which now appears to have been painted over Holbein's original cartoon, but in its present state the Barber-Surgeon's painting does the artist little credit.

Holbein's portraits can, in general, be divided into a few well-defined categories which persist throughout his mature work. To the first belong those in which the artist concentrated on the facial features of those portrayed, with comparatively little attention paid to potentially distracting details such as elaborate dress, background and accompanying objects. In its present state, the almost pathetic group portrait of *Holbein's Wife and Two Children* probably of 1528 (Plate 43), painted on paper and then applied to a panel, appears to belong to this category, although there was originally an architectural background which was cut away. The composition of this portrait is, incidentally, very close to various Madonna and Child groups by Leonardo. The chief representatives of this first category of portraiture are a large number of portraits dating from Holbein's second English period, including those of members of the Wedigh family (Plates 60 and 61) and *Sir Richard Southwell* (Plate 75). In these there was a gradual development in terms of the simplification of background, which came to have less and less texture and depth, while at the same time the sitters appear to have assumed increasingly static

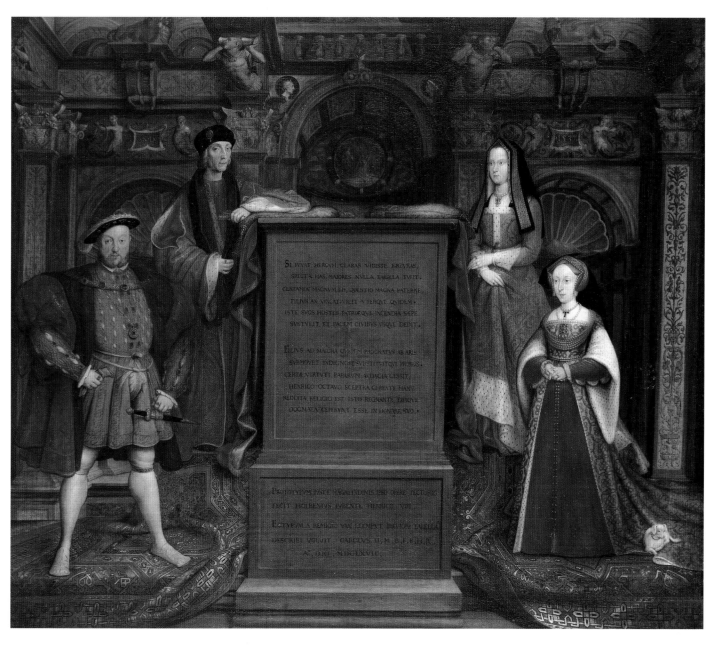

fig. 9
Remigius van LEEMPUT (d.1675)
Copy of Holbein's Whitehall Mural
HAMPTON COURT PALACE, Royal Collection. 1667.
Oil on canvas 88·9 x 98·7 cm.

The central plinth records the original inscription on Holbein's painting and adds five lines to the effect that this copy was made on the orders of King Charles II, with the date 1667. The painting which this canvas records was executed by Holbein on the walls of the Privy Chamber of Whitehall Palace c.1536–37. The Whitehall mural was destroyed by fire in 1698, and Leemput's copy is one of the best records of its original appearance. The painting was a propaganda work for the Tudor dynasty and showed Kings Henry VII and Henry VIII with their consorts Elizabeth of York and Jane Seymour. Roy Strong's idea that it was raised high above the royal chair and canopy of state is unsatisfactory as, from such a distance, the great detail, which is clearly evident in the surviving fragment of the cartoon (Plate 76), would not have been visible, and furthermore the perspective would not have matched up with the low viewpoint.

poses. It is fair to suggest that the quality of these portraits depends to a very large extent on the length of the sitting which the men and women depicted were prepared to grant to Holbein, but in the portrait of *Southwell* and the 1533 portrait of *Derich Born* (Plate 58) the artist achieved two of his most penetrating likenesses. Another example of the many Latin inscriptions in praise of Holbein's skill in verisimilitude occurs on Born's portrait and reads in translation: 'Here is Derich himself; add voice and you might doubt if the painter or his father created him.' The paintings of *King Henry VIII* and *Queen Jane Seymour* (Plates 82 and 83) and perhaps also those of *Edward, Prince of Wales* and *Charles de Solier, Sieur de Morette* (Plates 78 and 71) form a separate category, for their purpose was rather different. In these paintings the whole figure was treated with uniform care, isolated in the midst of a neutral background, so that the finished effect is similar to that produced by an icon.

In other portraits the artist's intention was quite different and, while the sitter was no less diligently shown, the objects which surround him were so brilliantly and carefully depicted that they may well occupy the observer's entire attention. This is especially the case with the portraits painted early in Holbein's second English period, such as *Georg Gisze* of 1532 (Plate 55) and '*The Ambassadors*' of 1533 (Plate 59), in which Holbein seems to have taken every opportunity to display his skill in distinguishing the different textures and layers of recession. The glass flask placed in front of Gisze's sleeve, for instance, appears to serve no very clear purpose except to have provided an opportunity to the painter to display his virtuosity in the depiction of velvet behind two layers of glass, or through the bunch of flowers. Ruskin particularly admired this portrait and wrote about it at length:

Gisze sits alone in his accustomed room, his common work laid out before him; he is conscious of no presence, assumes no dignity, bears no sudden or superficial look of care or interest, lives only as he lived – but for ever. It is inexhaustible. Every detail of it wins, retains, rewards the attention with the

continually increasing sense of wonderfulness. It is also wholly true. So far as it reaches, it contains the absolute facts of colour, form, and character, rendered with an unaccusable faithfulness.

The commission to depict the French ambassador Jean de Dinteville and his friend Georges de Selve, Bishop of Lavaur, the so-called '*Ambassadors*' (Plate 59) was used by Holbein for what is surely among his greatest *tours de force* as a painter. At the beginning of the twentieth century it was demonstrated that almost every item shown in this picture serves some very clear purpose in the elaborate programme. There are numerous *memento mori* symbols, typical of sophisticated Renaissance portraiture, for instance the curiously foreshortened skull in the foreground and that on Dinteville's cap brooch. In addition the exact time of day at which the men sat to Holbein can be calculated from the various instruments standing between the men on the buffet, while other objects must have been included to represent their interests. In the history of the portrait genre '*The Ambassadors*' must surely occupy a key position, as one of the boldest and most outspoken examples of a full-length double portrait ever painted.

Between these two types of portrait, the one with the figure isolated against a plain background, the other with the figure surrounded by a wealth of accumulated detail, is another category which contains many of Holbein's most penetrating portraits. Among these are the various studies of the artist's humanist friends from *Amerbach* (Plate 19) to the several studies of *Erasmus* (Plates 26 and 28), those of *Froben* (Plate 12) and *More* (Plate 33), in which the sitter is generally shown in a contemplatory attitude, or in the case of the Louvre *Erasmus* (Plate 28) actually composing one of his literary works.

In any discussion of Holbein's portraits the group of about eighty drawings in the Royal Library at Windsor Castle must play an important part. The studies range in date from those for *The More Family Group* (Plates 31–36) of 1526–28 to those of English courtiers and gentlemen with their wives produced in the last years of Holbein's life. The drawings were

apparently mostly intended merely as preliminary studies to be developed into finished paintings at a later date, otherwise they would surely not have survived together but would have been scattered among the descendants of the sitters represented. However, the study of *John Godsalve* (Plate 40), as that of *Edward, Prince of Wales*, in Basel (Plate 79), appears to have been intended as a finished work in its own right. The group of drawings in the Royal Collection include most of the surviving portrait studies made during Holbein's two English visits. The drawings were formerly gathered together in a 'Greate Book', which was recorded in the collections of Edward VI, Henry, Prince of Wales, and Charles I, as well as those of the Lumley family and of the Earls of Arundel, before finally returning to the Royal Collection at the end of the seventeenth century. There are, however, various stray drawings which must certainly date from Holbein's time in England and which are now scattered through public and private collections: the drawing of *Sir Nicholas Carew* in Basel (Plate 49), that of *Morette* in Dresden (Plate 70) and of the unknown *Scholar* or *Cleric* at Chatsworth (Plate 84) are among these.

It is generally claimed that the drawings from Holbein's two English visits can be distinguished by the different media employed, and it is possible to check this to a certain extent by linking the drawings to dated paintings in some cases. By this simple device, it appears that in the first period, to which the drawings of members of the More family and those of *Guildford* (Plate 38) and *Warham* (Plate 37), belong, Holbein employed black, white and coloured chalks, while in his second period, which certainly includes drawings such as those of the *Unknown Man* of 1535 (Plate 81), *Sir Richard Southwell* of 1536 (Plate 75) and *Queen Jane Seymour* of 1536–37 (Windsor Castle, Royal Collection), he used chalks, indian ink, applied with both pen and brush, and coloured washes on paper coated with a pink chalky preparation. But Holbein had himself used such a coated paper for his earliest drawings, for example the preparatory metalpoint studies for the 1516 pair of Meyer portraits in Basel, and both his father and brother used similar materials in their portrait studies (figs. 10 and 11). Indeed in Berlin there is a group of

portrait drawings by Hans Holbein the elder employing this technique, to which the portrait of *Jörg Bomheckel* (fig. 10) belongs. The drawings were made during the artist's last years in Augsburg (c.1509–16) and represent many of the citizens known to him there. None of these drawings was apparently worked up into an oil painting and they were instead intended as simple records, some of which were later used in crowd scenes in his religious paintings; the sitters in these drawings were in many cases identified by the artist himself. We may therefore conclude that the pink preparation of the paper in the drawings by Hans Holbein the younger of *Godsalve* and *Fisher* (Plates 40 and 47), for instance, which has formerly been used to date them to the second English period in spite of their similarity to earlier drawings, may instead be evidence of Holbein's continued use of prepared paper throughout his career, rather than of his readoption of the technique in c.1532 after having abandoned it about eight years earlier. In several of the Windsor drawings there has been a considerable amount of retouching, presumably to compensate for the loss of definition by the rubbing of the chalk outlines; in others there is a decline in quality, the inevitable result of the enormous number of portraits which Holbein was asked to paint during the 1530s and early 1540s. It has also been suggested that Holbein employed the so-called 'glass' method, as described by Dürer, to capture these likenesses, according to which the painter would trace the outlines of the sitter onto a pane of glass placed between himself and the subject. This would certainly help to account for the flattened impression created by some of the drawings. Various factors such as the poor condition of the drawings and the absence of comparative material in the form of contemporary portraits by other artists which might help us to date them on the basis of costume mean that it is seldom if ever possible to date those drawings whose sitters were not identified in the sixteenth century; the apparent lack of consistent stylistic development in Holbein's mature work is in fact confirmed by the internal evidence contained in these drawings. When all this has been said, however, the drawings at Windsor contain many passages

fig. 10
Hans HOLBEIN the elder (c.1465–1524)
Jörg Bomheckel
BERLIN, Staatliche Museen,
Kupferstichkabinett. Watercolour over
silverpoint heightened with white on prepared
paper 13·9 x 10·1 cm. Inscribed: jörg
bomheckel.

This drawing is one of the group of sixty-nine
portrait studies by the elder Holbein preserved
at Berlin. They are datable to between 1509
and 1516, when the artist was still active in
Augsburg, and some have been identified in
inscriptions added by the artist. The technique
employed throughout this group of drawings
was silverpoint, with some use of white and
red chalk and watercolour, on prepared paper;
the same technique was used by the artist's two
sons Ambrosius and Hans the younger
throughout their careers. The portrait drawings
by Holbein the elder in Berlin in many ways
represent a similar corpus to those by his son
in the Royal Collection.

of supreme quality, in the studies of the More family in particular. As we should expect from

the appearance of Holbein's finished paintings, he was meticulous in recording details of the

fabric and pattern and in depicting the texture of materials so that we can guess from a very

few strokes of the drawing instrument of what stuff a particular garment was made. The same

sensitivity to texture can be seen in the lovely costume drawings (Plates 17 and 18), which were

probably executed shortly before Holbein left Basel in 1526, and in the studies of animals from

about the same time (Plates 24 and 25).

Holbein's activity as a miniature painter is as enigmatic as many of the other aspects of his

career. His work in this genre is not documented but is described as of almost equal importance

fig. 11

Ambrosius HOLBEIN (c.1494–c.1519)
Head of a Young Man
BASEL, Offentliche Kunstsammlung,
Kupferstichkabinett. 1517.
Silverpoint and red chalk with some watercolour
on white prepared paper 20 x 15·3 cm. Signed
with monogram and dated 1517.

This drawing was presumably executed in Basel
in 1517, the year in which Ambrosius Holbein,
Hans the younger's elder brother, entered the
painters' guild there. The fact that it is both
signed and dated suggests that it may have been
intended as a finished work. The portraits by
Ambrosius Holbein are in general less
penetrating than those of his brother, and this is
one of the few surviving portrait drawings from
his hand. The technique is very similar to that
employed by Hans Holbein the younger.

to his painting in oil by authorities such as Karel van Mander and Nicholas Hilliard. Van
Mander stated that Holbein was taught the technique of miniature painting at the English court
by 'the painter Lukas', who is generally identified as the equally enigmatic Flemish artist Lucas
Horenbout. Van Mander continued: 'With Lukas he kept up mutual acquaintance and
intercourse, and learned from him the art of miniature painting, which, since then, he pursued
to such an extent, that in a short time he as far excelled Lukas in drawing, arrangement,
understanding, and execution, as the sun surpasses the moon in brightness.' Hilliard's statement
concerning Holbein as a miniaturist is perhaps even more revealing: 'Holbean's manner of
limning I have ever imitated and howld it for the best.' Until one of the many miniatures of

Thomas More based on Holbein's portraits is demonstrated to be an autograph work, all the surviving miniatures which can be ascribed to Holbein with some claim to authenticity appear to date from well into his second English period, that is from the time at which he is documented as a salaried servant of the crown. There are apparently no miniature portraits of members of the royal family from his hand, although *Solomon and the Queen of Sheba* (Plate 85) employs a miniaturist's technique, but the pair showing the sons of the first Duke of Suffolk called 'the Brandon boys' (Plates 86 and 87), the so-called '*Catherine Howard*' (Plate 89) and the *Lady Audley* (Plate 88), a work connected with a drawing at Windsor, clearly depict people belonging to the court circle. In addition to these, there is the group of self-portrait miniatures dated 1543 (Plate 91), the exquisite portrait of *Mrs Pemberton* (Plate 90), and a handful of others possibly including the pair of *Margaret Roper* and *William Roper* (Plates 92 and 93).

Throughout his life Holbein provided designs for craftsmen involved in the decorative arts and for publishers. His work in these fields is less well-known today, although there is an important group of his drawings for painted glass in Basel and for jewellery, metalwork and armour in the British Museum. It is interesting in this connection that More specifically described Holbein as 'artifex' rather than 'pictor' in his letter to Erasmus of December 1526. While his designs for painted glass can chiefly be dated to the artist's residences in Lucerne and Basel in the late 1510s and early 1520s, his designs for metalwork all apparently belong to his second English period. The studies for painted glass, which were mostly executed in monochrome, include several religious scenes and in particular a series of ten Passion scenes (Plates 14 and 15), each carefully framed within a slightly different architectural border. There is also a large group of designs for heraldic windows in which the shield for a prospective patron's coat of arms is left empty (Plate 16). In the mature designs for glass, as in the woodcuts, there is a simplification of detail and a broadening of treatment to enable the drawings to be reproduced easily and, furthermore, to be understood at a distance by the observer.

Holbein's designs for metalwork, seals, garters, bookbindings and different types of jewellery
are in many ways typical products of a sixteenth-century German artist. A large number of
such designs survive by artists such as Peter Flötner (fig. 12), incorporating the same *all'antica*
decorative vocabulary as that used by Holbein. Among the latter's best-known metalwork
designs is that for a cup with Hans of Antwerp's name inscribed along the edge of the lid (Plate
96) suggesting that it was to be made for, or more probably by, Hans of Antwerp during the
residence of both artists in London. The two designs for a decorated gold cup incorporating
Jane Seymour's motto and the initials 'H' and 'I' bound by a loveknot are, not surprisingly, more
elaborate (Plate 95) than the one for Hans's cup. From the evidence contained in the
decoration on this cup it is fair to assume that it was in some way connected with Henry VIII's
marriage to Jane in 1536; a cup that is certainly identifiable as the one made from these designs
was recorded in royal inventories until it was pawned by Charles I in 1625 and then melted
down four years later. The *Design for Sir Anthony Denny's Clock* (Plate 97) must have been among

the artist's last works, for Denny inscribed upon it that the clock itself was given by him to the King as a New Year's gift in 1544, following Holbein's death. These studies reveal Holbein's skilful and meticulous yet fluid penwork in a way that his portrait studies only rarely do; these characteristics were noted at the outset of his career, in the marginal illustrations to Erasmus's *Encomium Moriae* (Plate 9), and by the artist's last years they were naturally further refined.

No finished product of Holbein's collaboration with goldsmiths, armourers and jewellers has apparently survived. The same is inevitably true of his decorative design on a larger scale, about which there is tantalizingly little documentation. The decorative schemes executed in Basel and Lucerne have already been discussed. In 1527, during the artist's first visit to England, several payments were made to 'Master Hans' in connection with temporary buildings at Greenwich, set up to house the celebrations for the new alliance between England and France. In his capacity as comptroller to the King, Henry Guildford, who was portrayed by Holbein about this time (Plate 38), was responsible for the arrangements for these festivities, and from the wealth of *all'antica* decoration recorded in literary descriptions of these events it appears quite possible that Holbein may have been the artist involved; this would place his entry into royal service almost ten years earlier than the generally accepted date. Early in his second stay in England he was apparently commissioned by the merchants of the German Steelyard to design a triumphal arch through which Queen Anne Boleyn would pass on her coronation procession on 31 May 1533. The form of the arch is recorded in a drawing in Berlin (Plate 63); above it Apollo is shown seated amongst the Muses and within a bower on which perches an eagle. On the actual triumphal arch the eagle assumed the form of an imperial emblem, with two heads, and this overt reference to imperial power was, not surprisingly, noticed and unfavourably commented upon by the royal participants in the procession. Holbein was doubtless also responsible for decorative schemes of a more lasting nature in palaces and houses in England, although there is very little surviving evidence of such work. One such record exists in a design

for a chimney-piece for one of the royal palaces, which incorporates an elaborate allegorical scheme (Plate 100).

Holbein's activity in providing designs for publishers probably began during his apprenticeship, and his skill in this branch of art may have been one of the reasons why he and his brother Ambrosius moved from Augsburg to Basel in 1515. The pre-eminent place occupied by Basel for the printing of scholarly works dated from 1477, when Johann Amerbach, the father of Bonifacius, Holbein's friend (Plate 19), set up his press there. Froben (Plate 12) learnt his trade under Amerbach and from 1491 to 1513 worked in partnership with him. During the first two decades of the sixteenth century an enormous quantity of scholarly works passed through the presses of Amerbach and Froben, and the latter was aided considerably by the presence in the town of scholars such as Erasmus, who acted as Froben's chief literary adviser at this time. Among Holbein's first important designs was the *Scaevola and Porsena* title-page (Plate 101) which was frequently re-used by Froben after its first appearance in 1516. But his designs for woodcuts can only be truly appreciated after around 1522, when Holbein worked in partnership with the brilliant woodcutter Hans Lutzelberger. The latter was responsible for cutting Holbein's designs for Luther's New Testament, published in 1522 (Plate 102) and the Old Testament series, published in 1538 but designed over ten years earlier (Plates 105–108), as well as many others. The quality of both the designing and the cutting of these woodcuts is superb. Holbein gradually abandoned any attempt at creating a rich textural effect to equal that of Dürer's woodcuts, for instance, and aimed instead at a simplicity of line which succeeds in making his woodcuts monuments of that art. Once again his activity in this field was chiefly concentrated in his years in Basel, but he also provided designs for English publishers and was responsible for the title-page of the first complete English translation of the Bible, the Coverdale Bible, published in 1535 (Plate 104).

When Holbein died in 1543 his loss must have been felt even more profoundly in England

than in Basel, and his presence was of tremendous significance to the evolution of British art. He left a large number of portraits to be copied and used as models by the few native artists, many of whom must have worked in his studio at various times. In addition, his designs for projects in publishing and the decorative arts were of great importance in providing inspiration to artists, goldsmiths and other craftsmen, while the influence of his larger decorative schemes can be seen in buildings even after the time of Inigo Jones. After Holbein the next English artist of real note was Nicholas Hilliard who was born four years after Holbein's death. Nevertheless in Hilliard's *The Arte of Limning*, written c.1600, he expressed in a charming way the extent of the debt which both he and England owed to Holbein:

King Henry the eight a Prince of exquisit jugment and Royall bounty, soe that of cuning stranger even the best resorted unto him, and removed from other courts to his. Amongst whom came the most excelent Painter and limner Master Haunce Holbean the greatest Master Truly in both thosse arts after the liffe that ever was, so Cuning in both together and the neatest; and therewithall a good inventor, soe compleat for all three, as I never heard of any better than hee. Yet had the King in wages for limning Divers others, but Holbean's maner of limning I have ever imitated and howld it for the best, by Reason that of truth all the rare Siences especially the arts of Carving, Painting, Goudsmiths, Imbroderers, together with the most of all the liberall Siences came first unto us from the strangers, and generally they are the best and most in number. I heard Kinsard [?Ronsard] the great French poet on a time say, that the Ilands indeed seldome bring forth any Cunning man, but when they Doe it is in high perfection; so when I hope there maie come out of this ower land such a one, this being the greatest and most famous Iland of Europe.

BIBLIOGRAPHY

A. Chamberlain, *Hans Holbein the Younger* (London 1913).

H. von Einem, 'Holbeins "Christus im Grabe" ', *Abhandlungen der geistesund sozial-wissenschaftlichen Klasse 1960 der Akademie der Wissenscharaften und der Literatur* (Mainz 1960).

Exhibition of Works by Holbein and other Masters (Royal Academy, London, exhibition catalogue 1950–51).

P. Ganz, *Die Handzeichnungen Hans Holbeins des Jüngeren* (Berlin 1937).

P. Ganz, *The Paintings of Hans Holbein* (London 1950).

H. W. Grohn, *Hans Holbein der Jüngere als Maler* (Leipzig 1955).

H. W. Grohn and R. Salvini, *L'opera pittorica completa di Holbein il Giovane* (Milan 1971).

F. Grossmann, 'Holbein Studies-I' and 'Holbein Studies-II', *The Burlington Magazine* (1951).

M. F. S. Hervey, *Holbein's 'Ambassadors'* (London 1900).

Holbein and the Court of Henry VIII (The Queen's Gallery, London, exhibition catalogue 1978–79).

'The King's Good Servant' Sir Thomas More (National Portrait Gallery, London, exhibition catalogue 1977–78).

M. Levey, *Holbein's 'Christina of Denmark, Duchess of Milan'* (London 1968).

Die Malerfamilie Holbein in Basel (Kunstmuseum, Basel, exhibition catalogue 1960).

M. Netter, 'Hans Holbein d. J. "Madonna des Bürgermeisters Jacob Meyer zum Hasen" und ihre Geheimnisse', *Basler Jahrbuch* (1951).

K. T. Parker, *The Drawings of Hans Holbein in the Collection of H.M. the King at Windsor Castle* (London 1945).

D. Piper, 'Holbein the Younger in England', *Journal of the Royal Society of Arts* (1953).

A. E. Popham, 'Hans Holbein's Italian Contemporaries in England', *The Burlington Magazine* (1944).

F. Saxl, 'Holbein and the Reformation', *A Heritage of Images* (London 1970).

H. A. Schmid, *Hans Holbein der Jüngere. Sein Aufstieg zur Meisterschaft und sein englischer Stil* (Basel 1948).

R. Strong, *Holbein and Henry VIII* (London 1967).

A. Woltmann, *Holbein und seine Zeit. Des Kunstlers Familie, Leben und Schaffen* (Leipzig 1874–76).

R. N. Wornum, *Some Account of the Life and Works of Hans Holbein* (London 1867).

1 Table-top for Hans Baer
ZÜRICH, Schweizerisches Landesmuseum. 1515.
Tempera on wood 102 x 136 cm.
Signed and dated: HANS.HO . . . 1515.

This table-top was painted to commemorate Hans Baer's marriage on 24 June 1515. Baer was a citizen of Basel and the brother-in-law of Jakob Meyer, whose portrait Holbein painted in the following year (Plate 3). It provides the earliest evidence of Holbein's presence in Basel and is a fine example of the characteristically German style which was spread chiefly through woodcuts during the early years of the sixteenth century. The table-top has also been attributed to Hans Herbst, another painter active in Basel, with whom Holbein was associated at this time.

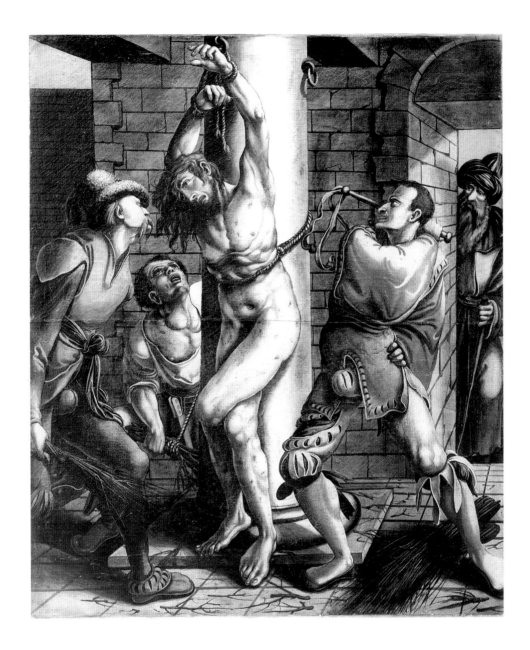

2 *The Flagellation of Christ*
BASEL, Offentliche Kunstsammlung.
Tempera and oil on canvas 137 x 115 cm.

The fact that *The Flagellation* is painted on canvas
suggests that this painting and the four other similar
Passion scenes, also in Basel, were intended as
temporary church decoration, perhaps for Holy Week.

There is an intensity about this scene which probably
indicates the influence of Grünewald, and there are
also features apparently derived from Dürer's series of
small woodcuts of scenes from the Passion. The style
seen in this early work seems to have disappeared from
Holbein's *oeuvre* around the mid-1520s when his
mature, polished style, rich in Italian influence,
replaced it.

3 Jakob Meyer
BASEL, Offentliche Kunstsammlung. 1516.
Oil and tempera on wood 38·5 x 31 cm.
Signed with a monogram and dated: 1516.

Jakob Meyer was elected Burgomaster of Basel in the year that this portrait was painted; he was the first commoner to hold this office. He was also the brother-in-law of Hans Baer for whom Holbein may have painted the table-top now in Zürich (Plate 1). Meyer married Dorothea Kannengiesser (Plate 4) as his second wife in 1513; their three children are shown with them and with Meyer's first wife in *The Meyer Madonna*, executed around ten years after this portrait (Plate 45).

4 *Dorothea Kannengiesser*
BASEL, Offentliche Kunstsammlung. 1516.
Oil and tempera on wood 38·5 x 31 cm.

This portrait was painted as the companion piece to that of *Jakob Meyer* (Plate 3), the sitter's husband, in 1516. The panels were formerly joined as a diptych, with the Meyer coat of arms on the outer face. Apart from the original physical linking of the two panels, they are also united by the architectural background and by the way in which the sitters look at one another.

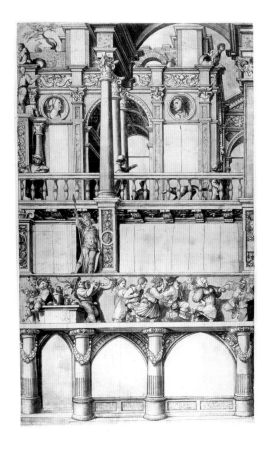

(*above left*)
5 *Preliminary Study for the Overall Design of the Main Façade of the Haus zum Tanz*
BASEL, Offentliche Kunstsammlung, Kupferstichkabinett.
Pen and ink with wash 53·7 x 36·5 cm.

The Haus zum Tanz in Basel, belonging to the goldsmith Balthasar Angelrot, was decorated with mural paintings by Holbein which were intended to cover the whole of the two street-fronts of the house. The main façade, for which this drawing was intended, was the shorter of the two and was situated on one of the major streets of Basel, the Eisengasse; the entrance to the house is shown on the left in the drawing. The extravagant foreshortening of the painted architecture was an attempt to compensate for the very limited space between this house and those on the opposite side of the street, a restriction which meant that the painted façades could be seen only with difficulty. This preliminary design has a freedom and fluency of handling typical of Holbein's mature style of draughtsmanship and seen to full advantage in his later designs for decorative objects (Plates 98 and 99). The Berlin drawing (Plate 6) is a more highly worked up version of this design, in which several details were altered. The Haus zum Tanz, with Holbein's other house-front decorations in Basel, was probably executed early in the 1520s; a copy of this drawing in Basel is dated 1520.

(*above right*)
6 *Overall Design for the Main Façade of the Haus zum Tanz*
BERLIN, Staatliche Museen, Kupferstichkabinett.
Pen and ink with coloured washes 57·1 x 33·9 cm.

This drawing is a more highly finished and coloured version of the Basel study (Plate 5). It contains a characteristically German mixture of the sophisticated Italian Renaissance style, full of such detail *all'antica* as the triumphal arch in the background, with native German types seen in the musical peasant frieze above the ground-floor level.

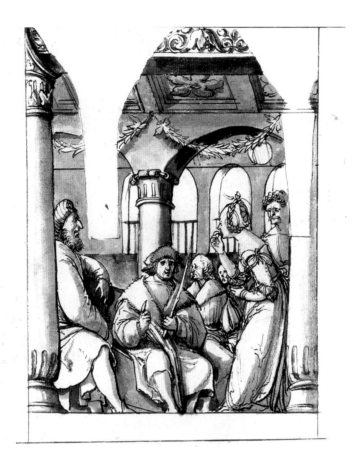

7 Leaena and the Judges
BASEL, Offentliche Kunstsammlung,
Kupferstichkabinett. 1517–18.
Pen and brown ink and wash 21·2 x 16·5 cm.

One of Holbein's chief commissions during his visits
to Lucerne in 1517 and 1519 must have been the
internal and external decoration of the house
belonging to the chief magistrate of the town, Jakob
von Hertenstein. Building work on the house was only
completed in 1517; it remained standing until 1825 and
prior to its demolition in that year all surviving traces
of Holbein's paintings on the façade were copied by a
group of local artists. From these copies it is possible
to reconstruct the original appearance of the house,
which made free use of a number of Italian decorative
devices. The façade decorated by Holbein consisted of
three principal storeys above a ground floor; the first-
and second-floor windows were decorative clusters of
arms and armour and above these windows was a
triumphal procession, clearly derived from Mantegna's
Triumph of Caesar (fig. 3). Between the windows of the
top storey were five scenes from ancient history
evidently chosen for their moral lesson: the space to
left of centre was occupied by a depiction of the story
of Leaena and the judges, for which this drawing was
the preparatory design. Leaena, the mistress of the
tyrant-slayer Aristogeiton, bit out her tongue to avoid
the temptation of betraying her lover during the trial.

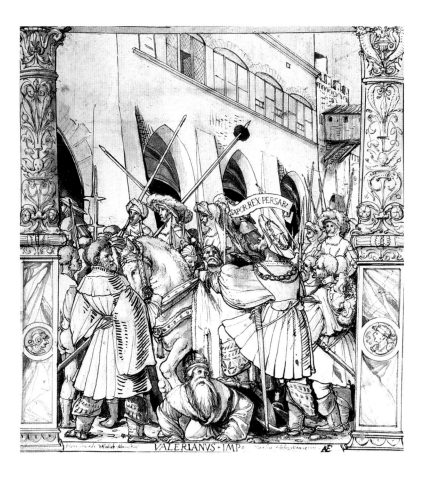

8 *Sapor and Valerian*
BASEL, Offentliche Kunstsammlung,
Kupferstichkabinett.
Pen and brown ink and wash with watercolour
28·8 x 27·3 cm.

Holbein's decorations in the Great Council Chamber
of Basel Town Hall were painted in two stages,
1521–22 and c.1530, after his return from the first visit
to England. The Rathaus, or Town Hall, which was
rebuilt in 1508–21, appears in the background of this
drawing. Holbein's decorative scheme consisted of

scenes from ancient history and from the Old
Testament, especially chosen for the moral lessons
they might provide to the councillors, set within a
fictive architectural framework; each scene was divided
from the others by a niche containing an allegorical
figure. On either side of the finished painting of *Sapor
and Valerian*, for which this drawing was a preliminary
sketch, were the figures of Wisdom and Temperance;
the scene depicted is the humiliation of the Emperor
Valerian by Sapor, King of the Persians, who used him
as a mounting block.

9 Marginal sketches in Erasmus's *Encomium Moriae*
BASEL, Offentliche Kunstsammlung,
Kupferstichkabinett. 1515–16.
Pen and ink.

This detail, showing Folly descending the steps of a
pulpit, is the last of several marginal sketches which
Holbein and other artists added to a copy of
Erasmus's *Encomium Moriae*, published by Froben in
Basel in 1515 and belonging to the scholar Oswald
Myconius, who left Basel for Zürich in 1516. It
provides one of the first datable examples of
Holbein's style of draughtsmanship and reveals that
the fluency which is so much a mark of his later
designs, in particular of those for the decorative arts,
was already present in embryo at the outset of his
career.

10 *Design for the von Hertenstein House*
BASEL, Offentliche Kunstsammlung,
Kupferstichkabinett. 1517–18.
Pen and brown ink and wash with watercolour
30·7 x 44·7 cm.

Like *Leaena and the Judges* (Plate 7), this design was for
the von Herstenstein house, decorated by Holbein
during his residences in Lucerne in 1517 and 1519.
The overall decorative scheme for the façade was
clearly related to that of the Certosa at Pavia, south of
Milan, completed in 1473, which Holbein could have
visited during a trip to Italy around this time. The
design incorporates the main entrance into the house
and a window to one side and is full of illusionistic
devices.

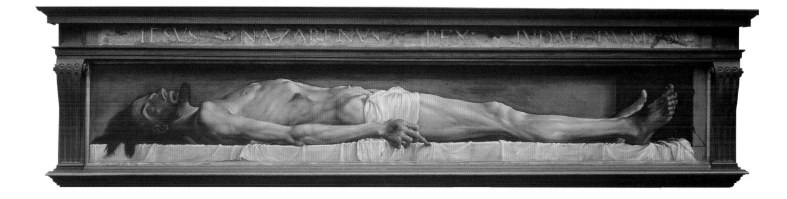

11 *Christ in the Tomb*
BASEL, Offentliche Kunstsammlung. 1521.
Oil and tempera on panel 30·5 x 200 cm.
Signed with monogram and dated: MDXXI.

This curious panel is described in the Amerbach
inventory as 'A picture of a dead man with the title
Jesus of Nazareth'. It may have formed the predella
panel of an altarpiece of the same nature as
Grünewald's *Isenheim Altarpiece* (Colmar, Musée
d'Unterlinden) of c.1515, the predella panel of which
also depicts the dead Christ. An alternative theory is
that the painting may have taken the place of a piece of
sculpture in an Easter Tabernacle. The flesh is
depicted with an uncanny realism: the flesh-tints are
green-grey in colour.

12 *Johannes Froben*
WINDSOR CASTLE, Royal Collection. c.1522–23.
Oil on panel 55·2 x 32·4 cm., including a later addition
at the top of 6·4 cm.

The printer Johannes Froben (1460–1527) was painted
by Holbein in Basel c.1522–23 and this painting
therefore belongs to the same period as the portraits of
Erasmus (Plates 26 and 28). With the elder Amerbach,
Froben was the most important printer in Basel at this
time, and many of his books of the second and third
decades of the sixteenth century were illustrated with
designs by Holbein (Plates 101 and 103) and his
brother Ambrosius. During his years of residence in
Basel Erasmus acted as literary adviser to Froben, and
it is probable that it was Froben who first introduced
Holbein to the scholar. This portrait may have been
incorporated with one of Erasmus in a diptych
recorded c.1600. The companion piece would have
been the portrait of *Erasmus* in the Royal Collection:
the original background behind Froben, now painted
over but visible in X-ray photographs, includes a
curtain which also appears in that portrait of *Erasmus*.
In the late 1620s the background of the *Froben* portrait
was painted in by Hendrick van Steenwyck the
younger, who was patronized both by the Duke of
Buckingham and King Charles I, to whom the pictures
were presented by Buckingham in 1627.

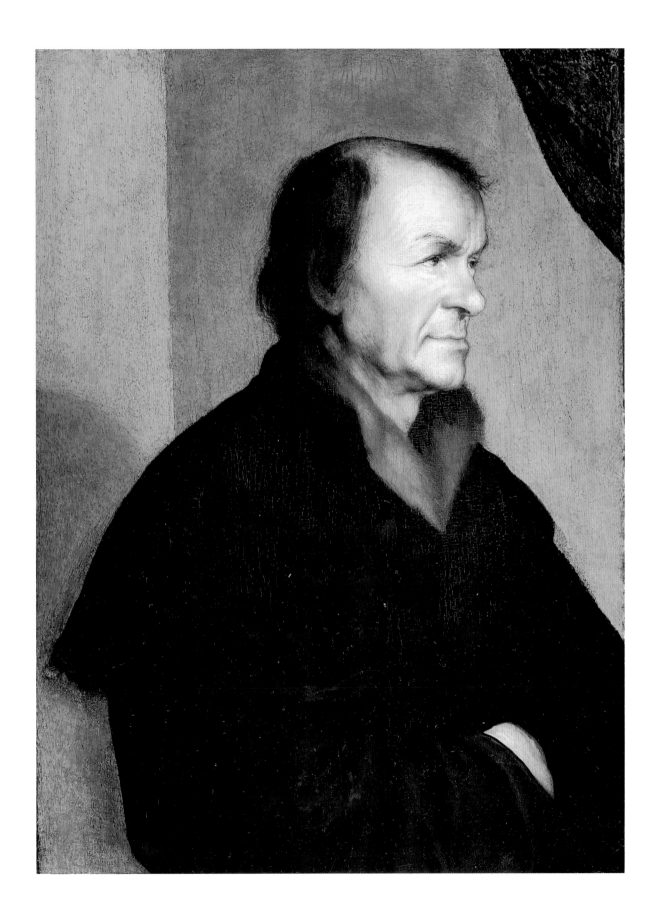

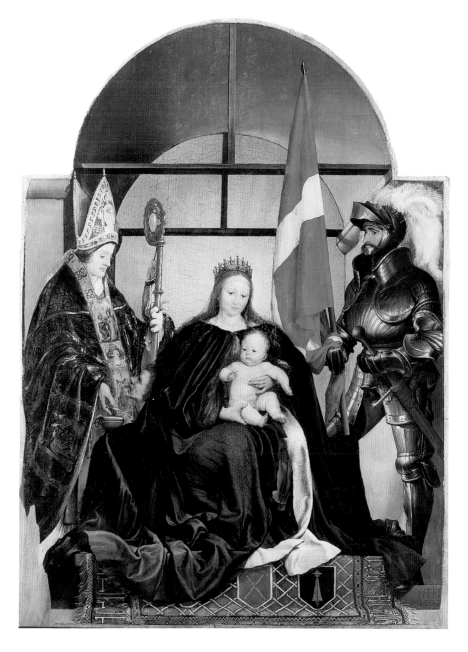

13 *The Solothurn Madonna*
SOLOTHURN, Museum der Stadt Solothurn. 1522.
Oil and tempera on panel 140·5 x 102 cm.
Signed with monogram and dated: 1522.

The Virgin is shown seated beneath a simple tunnel-vaulted structure with St Nicholas and St Ursus at either side. The figures are of a rather bulky and static form and, as in *The Meyer Madonna* of about five years later (Plate 45), they do not occupy more than the foreground plane. In this respect the composition departs from its north Italian models. The altarpiece was painted for Hans Gerster, the town archivist of Basel, and appears to use the features of Holbein's wife (Plate 43) for those of the Virgin.

(*above left*)

14 *Design for a Painted Glass Window with the Mocking of Christ*

BASEL, Offentliche Kunstsammlung, Kupferstichkabinett.

Pen and ink and wash 43·2 x 30·9 cm.

This drawing is one of a set of ten designs for painted glass windows with Passion scenes. It has an intensity of feeling typical of one aspect of Holbein's early style, which was clearly influenced by Grünewald.

(*above right*)

15 *Design for a Painted Glass Window with Pilate Washing his Hands*

BASEL, Offentliche Kunstsammlung, Kupferstichkabinett.

Pen and ink and wash 43·3 x 31 cm.

This drawing is another of the group of designs for painted glass Passion scenes. These designs were for painted rather than stained glass. The artist would paint on white glass which would then be re-fired. The panes of glass thus produced were used in both sacred and secular settings.

16 *Design for a Painted Glass Window with Two Unicorns*
BASEL, Offentliche Kunstsammlung,
Kupferstichkabinett.
Pen and ink with wash and watercolour 42 x 31·7 cm.

This drawing is one of a group of studies for heraldic
windows designed by Holbein during his residence in
Basel. These designs display a simplicity of outline and
contour common to all Holbein's mature work in this
genre, and the architecture has a sophistication typical
of the best northern art of c.1525, comparable to that
seen, for instance, in Mabuse's *Hercules and Dejanira* of
1516 (Birmingham, Barber Institute of Fine Arts).

17 *Costume Study: Noblewoman*
BASEL, Offentliche Kunstsammlung,
Kupferstichkabinett.
Ink applied with pen and brush and wash
29·1 x 19·8 cm.

18 *Costume Study: Lady of the Bourgeoisie*
BASEL, Offentliche Kunstsammlung,
Kupferstichkabinett.
Ink applied with pen and brush and wash
29·1 x 19·9 cm.

Both drawings come from a group of five sheets of
costume studies, two of noble dress, two of bourgeois
dress and one of courtesans' dress. They are valuable
documents for the history of fashion and are
comparable to those made by Dürer during his
Netherlandish journey about five years before these
drawings were executed by Holbein c.1526. The
noblewoman (Plate 17) wears a bridal cap, presumably
for her own wedding, and a jewel hung from a collar
inscribed, appropriately, with the words 'AMOR
VI[NCIT]'.

19 *Bonifacius Amerbach*
BASEL, Offentliche Kunstsammlung, 1519.
Oil on panel 28·5 x 27·5 cm.
Signed and dated: IO.HOLBEIN.DEPINGE
BAT.A.M.D.XIX.PRID.EID.OCTOBR.

This portrait was painted in the year that Amerbach, the son of a famous Basel printer and publisher, returned to his home town from Freiburg, where he had been studying. He was a considerable scholar and was awarded the chair in Roman Law at Basel University in 1525. Amerbach may first have met Holbein through Erasmus and his friendship with the artist continued throughout their lives: the vast collection of works by Holbein that Amerbach formed was the basis for the corpus of Holbein material in the Offentliche Kunstsammlung. This is the most striking portrait from Holbein's early years and it developed a formula frequently seen in Italy and in the art of Albrecht Dürer. The inscription attached to the tree is chiefly in praise of Holbein's skill in verisimilitude and is of a type frequently found in Holbein's pictures. To achieve this life-like effect the artist employed the *sfumato* technique which he must have learnt during his presumed but undocumented visit, or visits, to Italy.

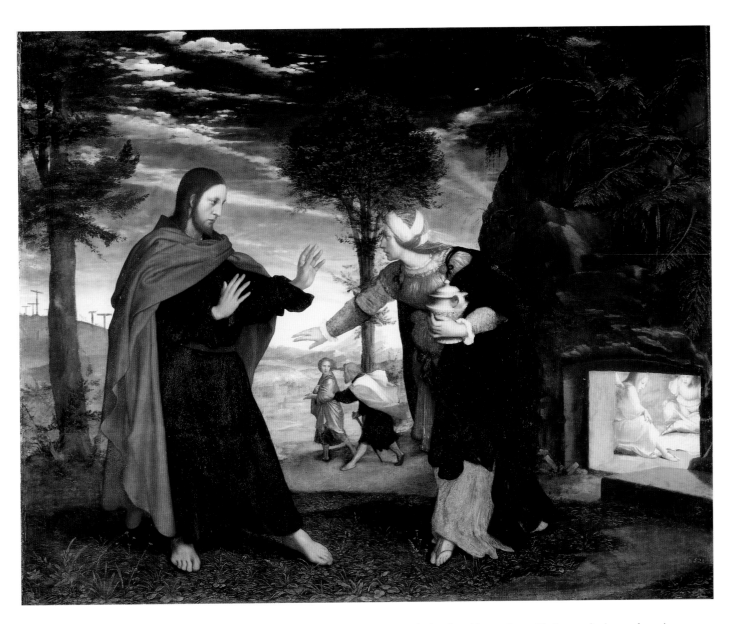

20 *Noli Me Tangere*
HAMPTON COURT PALACE, Royal Collection.
Oil on panel 76·7 x 95·2 cm.

This panel is curiously difficult to date, and its
presence in England indicated to some of Holbein's
biographers that it belonged to one of the artist's
periods of residence there. Owing to the iconoclasm in
Basel there are no strictly comparable works from his
years in Switzerland, but the similarity of the brilliant
lighting effects and the Grünewald-like intensity
suggest that *Noli Me Tangere* is close in date to *The
Passion Altarpiece* of c.1524 (Plates 21–23).

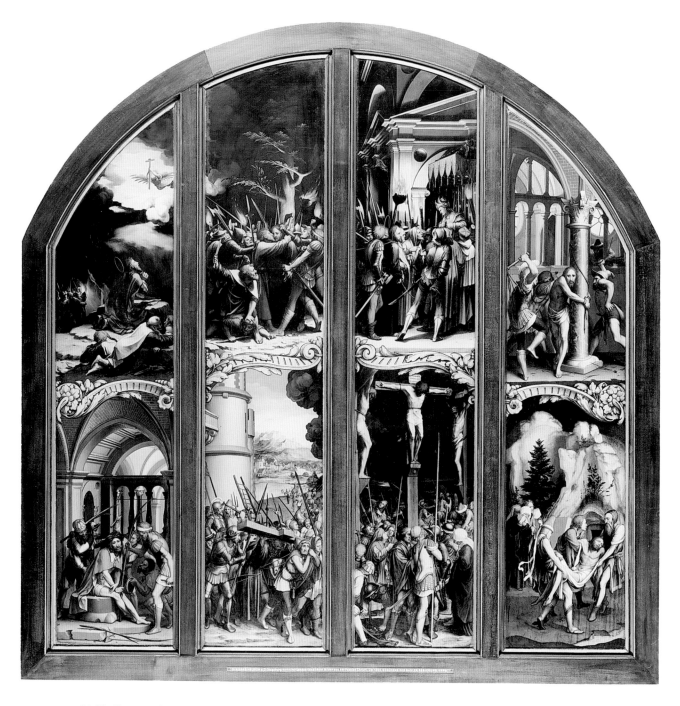

21 *The Passion Altarpiece*
BASEL, Offentliche Kunstsammlung. c.1524.
Oil and tempera on panel. Total height: 149·5 cm.;
width of individual panels: 31 cm.

This so-called altarpiece may in fact represent the
shutters of an actual altarpiece which has not survived.
The eight individual scenes of the Passion are
represented with striking intensity of colour within the
arched shape of the frame.

(*above left*)
22 *The Passion Altarpiece: Christ on the Mount of Olives,*
detail of Plate 21.

This scene occupies the top left-hand area of *The Passion Altarpiece*. The image is presented with great simplicity, and the main effect is made by the celestial light falling from the right on Christ's face and shoulder and on the sleeping forms of the Apostles in the foreground.

(*above right*)
23 *The Passion Altarpiece: The Crucifixion,*
detail of Plate 21.

The Crucifixion appears as the penultimate of the eight Passion scenes, to right of centre in the lower row of *The Passion Altarpiece*. There are numerous features which appear to have been influenced by Italian art, from the form and technique of the crucified figure to the poses of soldiers standing in the foreground.

24 *Study of Lambs*
BASEL, Offentliche Kunstsammlung,
Kupferstichkabinett.
Watercolour and wash 20·7 x 24·6 cm.

25 *Study of a Bat*
BASEL, Offentliche Kunstsammlung,
Kupferstichkabinett.
Watercolour and wash 16·6 x 27·9 cm.

These studies are generally ascribed to Holbein's
residence in Basel and are similar in many ways to the
elder Holbein's studies of animals now preserved in
the museums of Erlangen, Bamberg and Basel,
among others.

(right)
26 *Desiderius Erasmus*
Private collection. 1523.
Oil on panel 76·2 x 51·4 cm.

This painting is dated 1523 on the cover of one of the
books on the shelf in the top right-hand corner and is
probably to be identified with one of the two portraits
which Erasmus sent to England before June 1524, one
of which was a gift for Warham (Plate 37). The Greek
inscription along the book held by Erasmus reads in
translation: 'the Herculean Labours of Erasmus of
Rotterdam'. The Latin couplet on the edge of the
book that bears the inscribed date refers to Holbein's
powers of portraiture in complimentary terms and was
presumably composed by Erasmus himself: '[IL]LE
EGO IOANNES HOLBEIN NON FACILE
[VLL]VS [TAM] MICH[MIM VS] ERIT QVAM
MICHI[MOMVS] ERAT.'

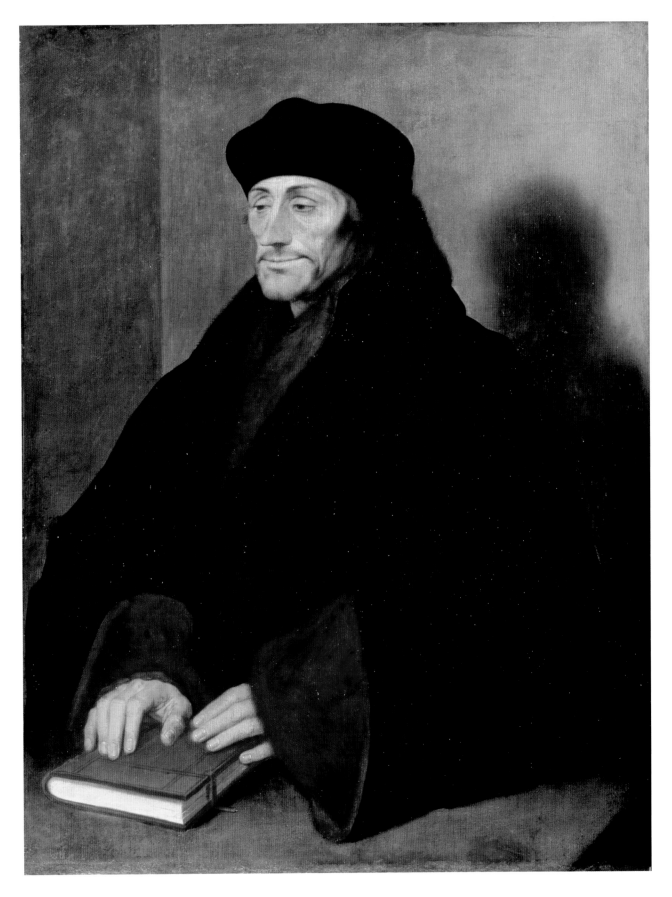

27 *Studies of Hands*
PARIS, Musée du Louvre, Cabinet des Dessins. 1523.
Silverpoint and black and red chalk on prepared paper
20·6 x 15·5 cm.

This sheet of studies provides one of the pieces of
evidence that the two portraits of *Erasmus* by Holbein
(Plates 26 and 28) were executed very close in time.
The study of the right hand was used for the Louvre
painting, and those of the left were used for the other
painting.

(*opposite*)
28 *Desiderius Erasmus*
PARIS, Musée du Louvre. 1523.
Oil on panel 43 x 33 cm.

One of several portraits painted by Holbein of
Erasmus, this panel was almost certainly executed in
1523 when both the artist and the sitter were resident
in Basel. They became close friends, and it was
through Erasmus that Holbein met Sir Thomas More
during the artist's first visit to London. In contrast to
the previous portrait (Plate 26) the scholar is here
shown in pure profile as he is represented, for instance,
on the medal of c.1519 designed by Quentin Metsys.
The writing on the sheet of paper in front of Erasmus
is clearly legible as the opening words of his
Commentary on the Gospel of St Mark, on which he was
working in 1523. This painting has been identified as
the second portrait despatched by Erasmus to England
in 1524.

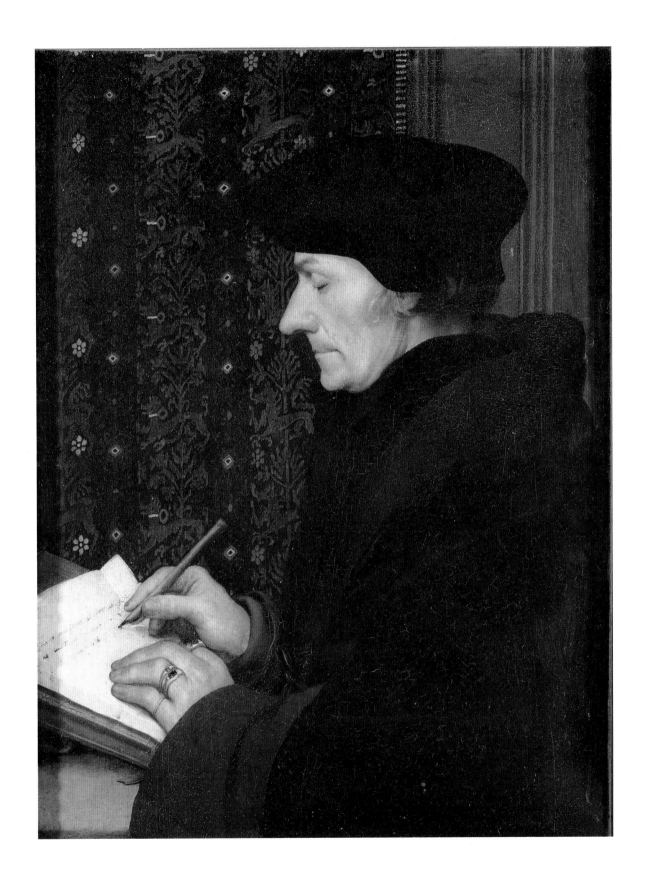

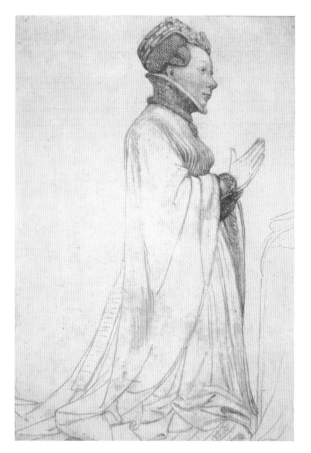

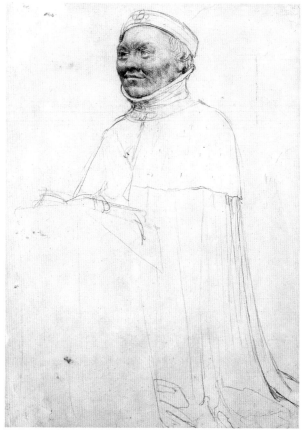

(*above left*)
29 *Kneeling Figure of Jeanne de Boulogne, duchesse de Berry*
BASEL, Offentliche Kunstsammlung,
Kupferstichkabinett. c.1524.
Black and coloured chalks 39·6 x 27·5 cm.

(*above right*)
30 *Kneeling Figure of Jean de France, duc de Berry*
BASEL, Offentliche Kunstsammlung,
Kupferstichkabinett. c.1524.
Black and coloured chalks 39·6 x 27·5 cm.

Holbein's journey to France in 1524 is recorded in a letter by Erasmus stating that the artist had taken a portrait of him to France; the visit is confirmed on the evidence provided by these two drawings depicting the kneeling figures which were at that time on either side of the High Altar of the Sainte Chapelle in the palace at Bourges; the figures were partially destroyed during the French Revolution. These drawings apparently represent Holbein's first use of black and coloured chalks on unprepared paper and are very beautiful and carefully worked examples of that technique. It is suggested that he learnt this method of draughtsmanship during his visit to France and his use of it is conspicuous in the five or so years after his visit: the preparatory studies for *The Meyer Madonna* (Plate 45) are in coloured chalks, as are the drawings for *The More Family Group* (Plates 32–36) and other studies datable to Holbein's first English visit. At the time of his French visit Holbein had already been using chalk as a drawing instrument for some time, but always on coated paper, as in the studies of hands (Plate 27) for the *Erasmus* portraits of 1523.

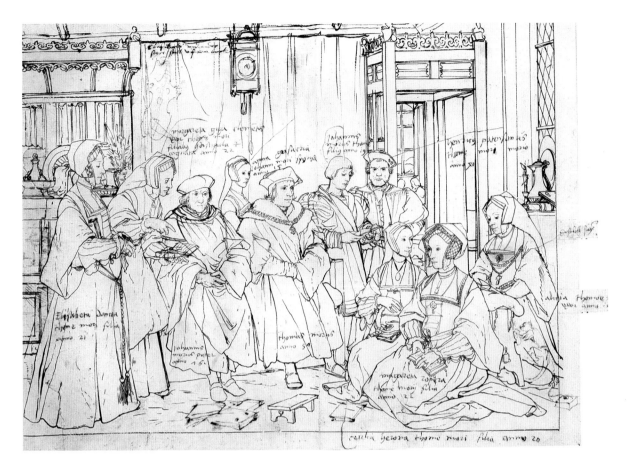

31 *The More Family Group*
BASEL, Offentliche Kunstsammlung,
Kupferstichkabinett. 1528.
Pen and ink 38·8 x 52·4 cm. Inscribed overall by both
Holbein and Nicolaus Kratzer.

This drawing provides us with the best evidence for
the final appearance of Holbein's lost painting of the
family of Sir Thomas More, seated in their house in
Chelsea. The painting itself, executed in tempera on
linen or canvas, was the major work of Holbein's first
English stay from 1526 to 1528; it was destroyed by
fire in the eighteenth century but is also recorded in
several later versions in oil. This drawing was taken
from London to Erasmus in Basel, probably by the
artist himself. The annotations are mostly in the hand
of Nicolaus Kratzer, tutor to More's household (Plate

46): he noted the age and identity of each sitter.
Another hand, perhaps that of Holbein himself, noted
that the hanging viol should be replaced by musical
instruments lying on the buffet and that Dame Alice
should sit instead of kneel. Such suggestions, coupled
with the possibility that Holbein himself transported
the drawing to Basel, provide some evidence that the
painting was unfinished when Holbein left England in
1528. In September 1529 Erasmus wrote both to More
and to More's eldest daughter Margaret Roper (Plate
92) expressing his admiration for Holbein's skill in
portraying his dear friends: 'so well has Holbein
depicted the whole family for me that if I had been
with you I could not have seen more'. The drawings of
members of the More family in the Royal Collection
(Plates 32–36) are preparatory studies for the
destroyed painting.

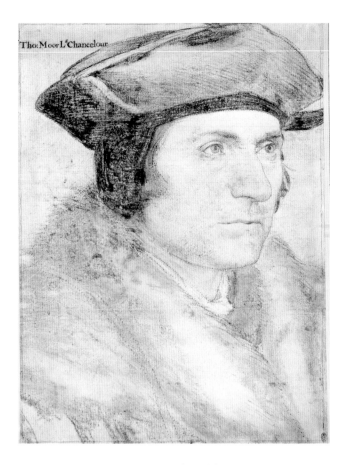

(above)
32 *Sir Thomas More*
WINDSOR CASTLE, Royal Library. 1526–28.
Black and coloured chalks 39·7 x 29·8 cm.

This study is connected with both *The More Family Group* (Plate 31) and the independent half-length portrait of *More* in the Frick Collection (Plate 33). Holbein had spent much of his time in England resident in More's house. By the time that the artist reached England in 1526 he had already worked on providing illustrations for some of More's writing (Plate 101). The outlines of this drawn portrait have been pricked, apparently for transfer to a panel of canvas.

(opposite)
33 *Sir Thomas More*
NEW YORK, Frick Collection. 1527.
Oil on panel 74·2 x 59 cm. Inscribed: M.D.XXVII.

This portrait is almost certainly identifiable as the picture painted by Holbein in London in 1527; X-rays taken in 1952 reveal that the position of the head changed during the painting. Here More appears in his late forties, in a pose similar to that in which he was shown in the group portrait of his family (see Plate 31), which was contemporary to this panel. Holbein's connection with More, to whom he was introduced by Erasmus, was crucial to the success of his first visit to England. More became a member of the king's council in 1517, hence the collar of 'SS' around his neck, and four years later he was knighted and appointed Sub-Treasurer. His appointment as Lord Chancellor in 1529, following the fall of Wolsey, was short-lived for, an intensely religious man, he could not agree to Henry VIII's divorce. He therefore resigned his office in 1532, the year of Holbein's return to England; two years later he was committed to the Tower and in July 1535 he was executed.

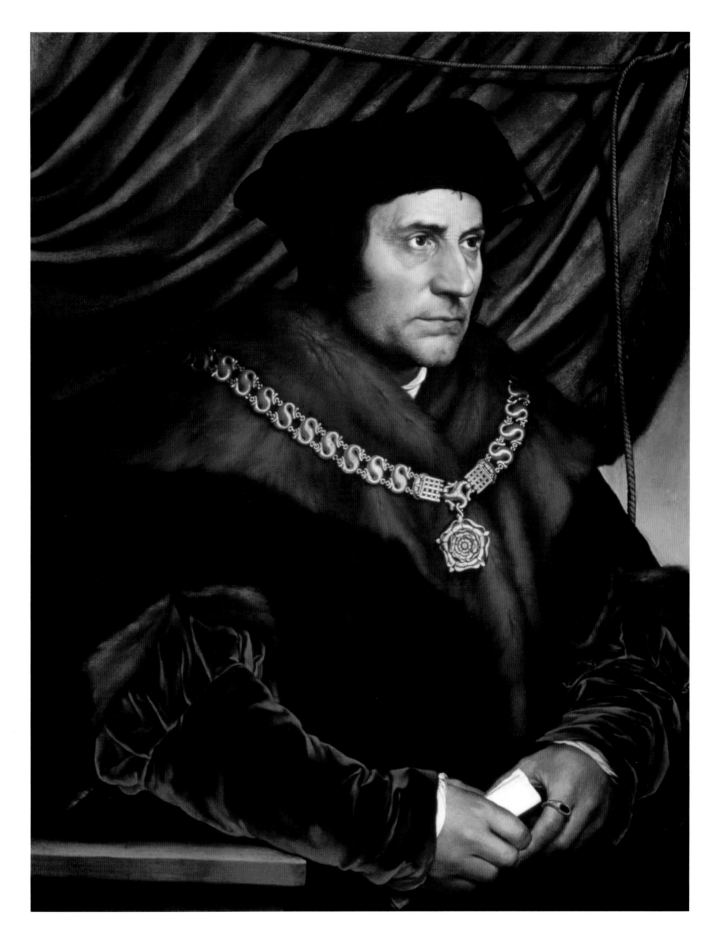

34 *Sir John More*
WINDSOR CASTLE, Royal Library. 1526–28.
Black and coloured chalks 35·1 x 27·3 cm.

Sir John was Thomas More's father and an important
lawyer. Thomas was his second child and the eldest
son of Sir John's first marriage and provided a home
for his father during his later years.

35 *John More the younger*
WINDSOR CASTLE, Royal Library. 1526–28.
Coloured chalks 38·1 x 28·1 cm.

John More was the only son and youngest child of Sir
Thomas More. He is portrayed here as he appeared in

The More Family Group, in which he was shown with his
future wife, Anne Cresacre (Plate 36) whom he
married in 1529. The drawing displays a freedom of
touch and handling, for instance in the sleeve and
hand, seldom found in the portrait drawings at
Windsor.

36 *Anne Cresacre*
WINDSOR CASTLE, Royal Library. 1526–28.
Black and coloured chalks 37·3 x 26·7 cm.

Anne Cresacre, an only child and the heiress of

Edward Cresacre of Yorkshire, was one of Thomas
More's many wards, and at the time of the painting of
The More Family Group she was betrothed to his son,
John, whom she married in 1529. The couple
produced several children.

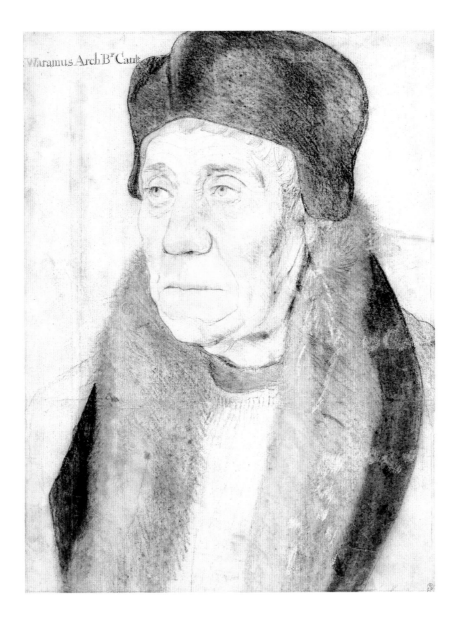

37 *William Warham, Archbishop of Canterbury*
WINDSOR CASTLE, Royal Library. 1527.
Black and coloured chalks 40·1 x 31 cm.

William Warham (c.1450/56–1532) was a close friend
of Erasmus and must consequently have met Holbein
soon after the artist's arrival in England. In 1524
Erasmus had sent Warham a portrait of himself
painted by Holbein, and the portrait of Warham, for
which this drawing was a preparatory study, was
intended as a gift for Erasmus. The portrait of *Warham*
in the Louvre, dated 1527, is generally identified with
this painting. It is probably significant that the pose
adopted by Warham in this picture is very close to that
of *Erasmus* (Plate 26), which may formerly have
belonged to Warham. He was appointed Archbishop
of Canterbury in 1502 and in this office clashed with
Wolsey, who was Archbishop of York, but they
worked together for Henry VIII's divorce from Queen
Catherine of Aragon, although they both died before it
was finalized.

38 *Sir Henry Guildford*
WINDSOR CASTLE, Royal Collection. 1527.
Oil on panel 81·4 x 66 cm. Inscribed (at a later date):
Anno D: MCCCCCXXVII Etatis Suæ XL. IX.

This portrait is one of the few datable works from
Holbein's first English visit, and it was painted as a
pendant to the portrait of *Lady Guildford* now in St
Louis (Plate 39). A preparatory drawing for the head in

this painting is also at Windsor. Guildford held several
high offices in the household of King Henry VIII,
including that of Comptroller, as indicated by the staff
held by him in this portrait. His services were rewarded
when he was elected a Knight of the Garter in 1526:
he is shown wearing the collar of that Order in this
portrait. The evidence concerning the sitter's age as
given in this inscription is contradicted by Guildford's
declaration that his age was forty in 1529.

39 *Mary Wotton, Lady Guildford*
ST LOUIS, St Louis Art Museum. 1527.
Oil on panel 87 x 70·5 cm. Inscribed and dated:
ANNO MDXXVII AETATIS SVAE XXVII.

This portrait was painted as a pendant to that of *Sir Henry Guildford*, the sitter's husband (Plate 38). There is a drawing of Lady Guildford in Basel in which she is similarly dressed but assumes a more frontal pose.

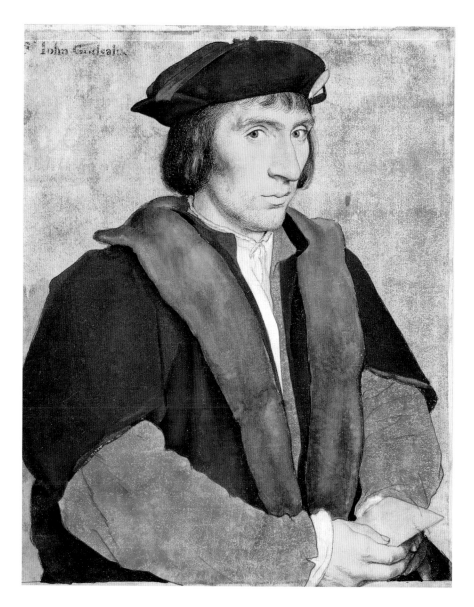

40 *John Godsalve*

WINDSOR CASTLE, Royal Library. c.1528.
Black and coloured chalks, black ink applied with pen
and brush, watercolour and bodycolour on pink
prepared paper 36·7 x 29·6 cm.

In the past this drawing was held to have been almost
entirely overpainted, but this is not now thought to be
the case. The drawing and modelling in the face are
certainly of the highest quality, and the portrait has a
degree of finish, particularly in the inclusion of details
such as a foreground ledge, suggesting that it was not
intended as a preparatory work for another picture but
rather, like the portrait of *Edward, Prince of Wales, with a*

Monkey (Plate 79), was a work of art in itself. No
related painting is known, although the sitter appears
in another portrait, attributed to Holbein, in the
Johnson Collection in the Philadelphia Museum of Art
and with his father Thomas in an autograph work in
1528 in Dresden (Plate 41). On the basis of its
technique this drawing is generally dated to early in
Holbein's second English period. It is quite possible,
however, that Holbein continued to use a chalky
preparation for his drawings, albeit intermittently,
throughout the later 1520s and so this drawing may be
dated c.1528. The sitter's age does not appear to
be radically different to that in the Dresden
double portrait.

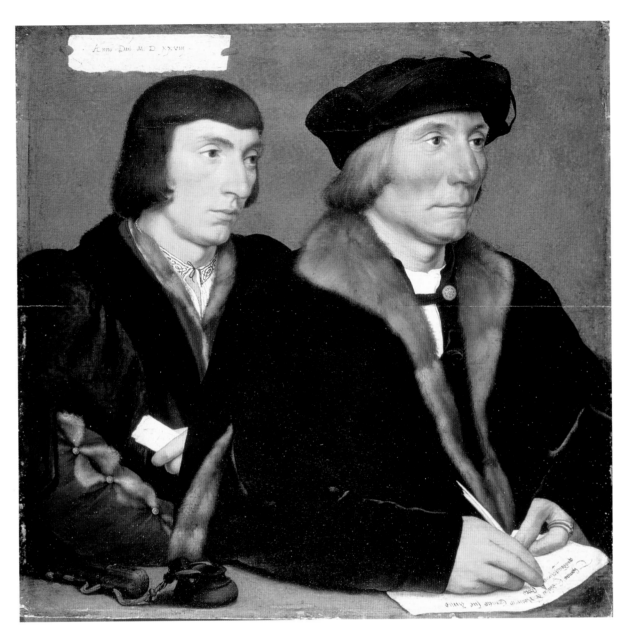

41 *Sir Thomas Godsalve and his Son John*
DRESDEN, Staatliche Gemäldegalerie. 1528.
Oil on panel 35 x 36 cm. Inscribed and dated:
Thomas Godsalve de Norwico Etatis sue Anno
quadragesimo septo.

This painting, like the portrait of *Kratzer* (Plate 44), is
dated 1528 and therefore was executed at the end of
Holbein's first stay in England. Thomas Godsalve was
a Norfolk landowner and an intimate friend of
Thomas Cromwell, who was apparently responsible

for furthering the career of his son John: in November
1531 the elder Godsalve wrote to Cromwell thanking
him for kindnesses shown to his son and sending him
'half a dozen swans of my wife's feeding'. John
Godsalve held several minor offices under Henry VIII
before being knighted in 1547 and appointed
Comptroller of the Mint in the reign of Edward VI.
He had connections with the German Steelyard, for
which Holbein worked during the early years of his
second visit, and was portrayed by Holbein in another
pose in a drawing at Windsor (Plate 40).

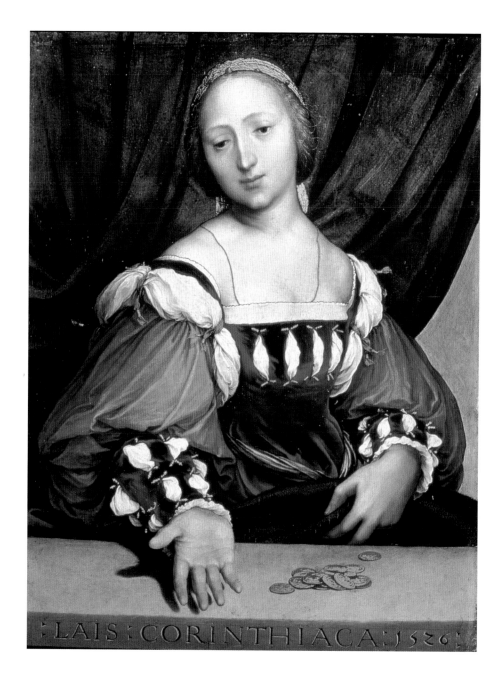

42 *Laïs Corinthiaca*
BASEL, Offentliche Kunstsammlung. 1526.
Oil on panel 35·6 x 26·7 cm. Inscribed and dated:
LAIS:CORINTHIACA:1526.

Laïs Corinthiaca and its pendant *Venus and Amor*, also in
the Offentliche Kunstsammlung, are described in the
1586 catalogue of the Amerbach collection as 'Zwie
täfelin doruf eine Offenburgin conterfehet ist vf eim
geschriben Lais Corinthiaca, die ander hat ein Kindin
by sich.' The model for both of these paintings is,

therefore, identifiable as the artist's mistress,
Magdalena Offenburg, who is appropriately shown
here in the guise of Laïs of Corinth, the mistress of
Apelles. On the basis of this identification it appears
that Magdalena Offenburg also posed for the Virgin in
The Meyer Madonna (Plate 45). The two paintings are
rich in Italian references and in particular to works by
Leonardo, from whose art Holbein must surely have
learnt the *sfumato* technique which is such a striking
feature of the *Laïs*.

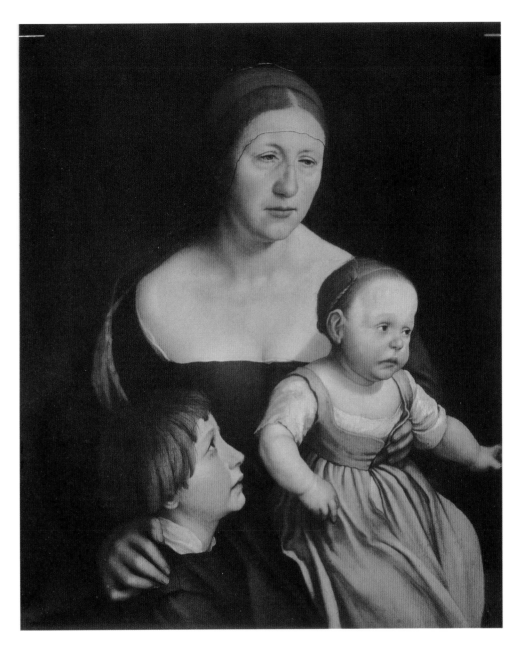

43 *Holbein's Wife and Two Children*
BASEL, Offentliche Kunstsammlung.
Oil on paper, backed on wood 77 x 64 cm.
Inscribed: 152(?).

This life-size portrait group was originally painted on four sheets of paper, and at a later date the figures were cut around and the whole was mounted on a panel. The original background destroyed at this time was similar to that seen in early portraits such as those of *Jakob Meyer* and *Dorothea Kannengiesser* (Plates 3 and 4), with pilasters and an ornamented frieze. The last figure of the date in the inscription was also cut away

at this time, but the painting is normally assigned to the period after Holbein's return to Basel following his first visit to England, on the basis of the ages of his children. While Holbein was working in London his family continued to reside in Basel, where the artist visited them only very occasionally. His will, made shortly before his death in 1543, provided for two infants who were presumably his illegitimate offspring in London. The composition of this picture surely derived from Italian prototypes and in particular from paintings employing pyramidal groupings evolved by Leonardo and Raphael during the first decade of the sixteenth century.

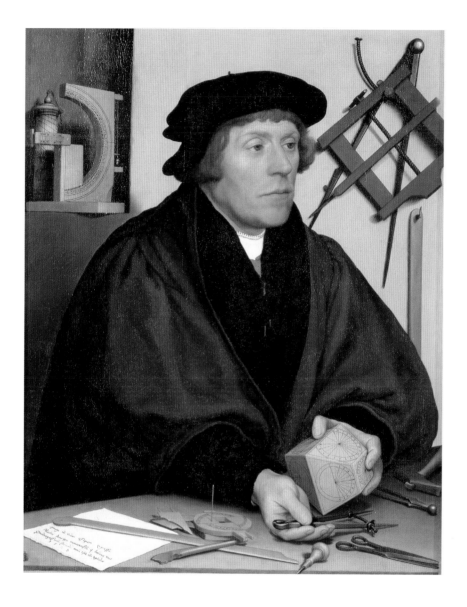

44 *Nicolaus Kratzer*
PARIS, Musée du Louvre. 1528.
Oil on panel 83 x 67 cm. Inscribed and dated: Imago
ad vivam effigiem expressa Nicolai Kratzeri
monasensis 9 [i] bavarus erat quadragessimu [primu]
annu tpre [tempore] illo [com]plebat 1528.

Nicolaus Kratzer left his native Germany for England
in 1517–18 and by 1520 had entered the King's service
as an astronomer; he appears to have continued in
royal employment until the time of his death around
the middle of the sixteenth century. In 1521 More
described Kratzer as 'a great friend of mine and very
skilled in astronomy', and he gave lessons in
mathematics and astronomy to members of More's
household. Kratzer was probably responsible for
adding the names and ages of the sitters to the
drawing of *The More Family Group* presented by More
to Erasmus (Plate 31). In 1520 he had been present at
one of Erasmus's sittings for Dürer in Antwerp (fig. 8).
Among King Henry's New Year's gifts in 1529 was a
manuscript of Nicolaus Kratzer's *Canones Horoptri*
which was written out by Peter Meghen and decorated
by Holbein; it is now in the Bodleian Library, Oxford.

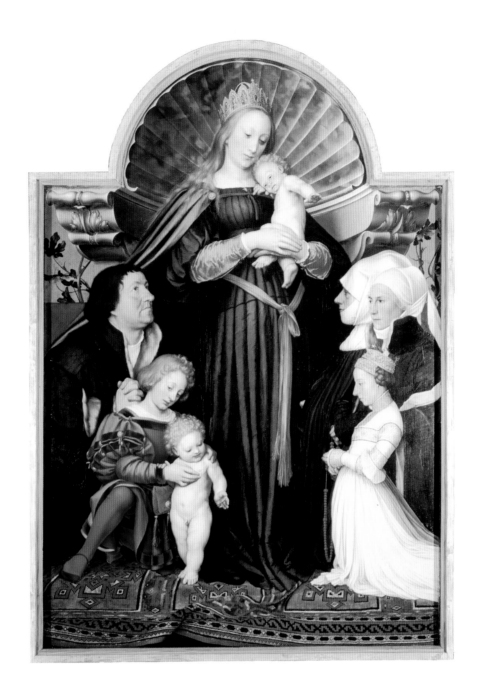

45 *The Meyer Madonna*
DARMSTADT, Schlossmuseum.
Oil on panel 146·5 x 102 cm.

This altarpiece was commissioned for the chapel of the
Castle of Guldendingen near Basel by Jakob Meyer
whom Holbein had portrayed in 1516 (Plate 3). It is
curious in showing Meyer's two wives, the first of
whom had died in 1511; it also depicts his two young
sons, who both died in 1526, the year in which Holbein
may have begun work on this painting. X-rays have
revealed that the artist made various alterations to the
picture at an advanced stage, and the inclusion of

Meyer's first wife may, therefore have been an
afterthought. The head of the daughter, Anna, was also
altered. It has been suggested that these changes were
made on Holbein's return to Basel from England in
1528. Preparatory studies exist for some of the heads.
There are numerous Italian features in this altarpiece,
from the composition itself, which follows the *Madonna
della Misericordia* type, and the use of *sfumato* in the
modelling, to the beautifully foreshortened arm of the
Christ Child, which must surely be related to the
Virgin's stance in Leonardo's painting of *The Virgin of
the Rocks* (fig. 6).

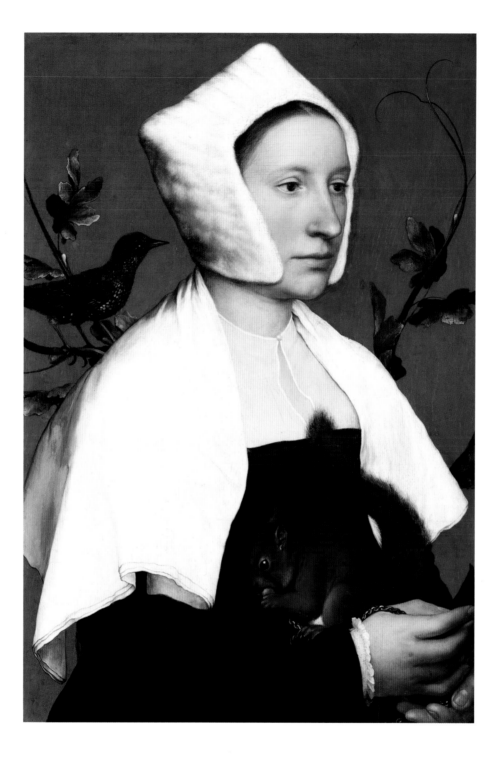

46 *Unknown Lady with a Squirrel, now identified as Anne Lovell, wife of Francis of East Harling, Nolfolk*
LONDON, National Gallery.
Oil on panel 54 x 38·7 cm.

The identity of the sitter in this charming portrait is now known and it is probable that the portrait dates from Holbein's first English period. The fur hat which she wears in similar to one worn by Thomas More's adopted daughter, Margaret Giggs, in *The More Family Group* (Plate 31).

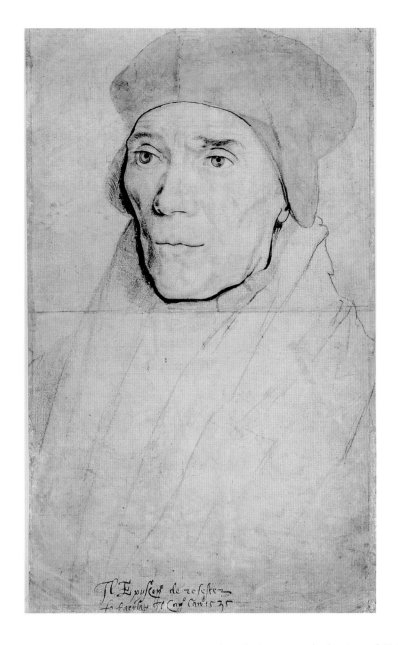

47 *John Fisher*
WINDSOR CASTLE, Royal Library.
Black and coloured chalks, reinforced with brush and
pen and black ink, with some watercolour on pink
prepared paper 38·3 x 23·4 cm.
Inscribed and dated in a contemporary hand: II
Epyscop° de roscster fo . . . ato II Capo lano 1535.

A generation younger than Warham, Fisher was
appointed Bishop of Rochester in 1504; owing to his
opposition to the royal divorce he was imprisoned in
1534 and executed in the following year, as the
inscription states. At the time of Holbein's return to
England in 1532 Fisher was already out of favour and
it is therefore unlikely that this portrait was drawn
then, in spite of the fact that the pink priming and
watermark of the paper are similar to those of other
drawings dating from Holbein's second English period.
It is very probable that Holbein did not temporarily
abandon the use of coloured preparations for his
drawings c.1524–32, as has been thought, and there is
therefore no reason why this drawing should not have
been produced during the artist's first visit.

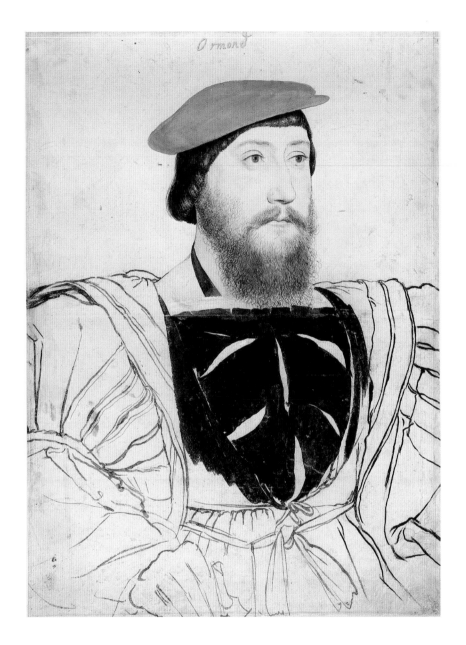

48 *Thomas Boleyn, first Earl of Wiltshire and of Ormond*
WINDSOR CASTLE, Royal Library.
Black and coloured chalks, black ink applied with pen
and brush and watercolour on pink prepared paper
40·5 x 29·4 cm.

Owing to the inscription 'Ormond', this drawing is
usually said to represent Anne Boleyn's father, the
Treasurer of the Household in 1522 and Lord Privy
Seal in 1530. No surviving picture can be connected
with this drawing, which is among the most striking of
Holbein's portrait studies, both in terms of colour and

of technique. The free handling of the drapery, in
brush and indian ink, is comparable to that in black
chalk in the drawing of *John More the younger* (Plate 35),
although the Boleyn portrait shows markedly more
meticulous treatment of the facial features and hair.
On the basis of technique this study has generally been
dated c.1535, although a date somewhat earlier and less
close to his daughter's disgrace might make the
identification more likely. If this drawing was, in fact,
executed during Holbein's first English period then
Boleyn would have been in his late forties, which
seems a quite likely age for this sitter.

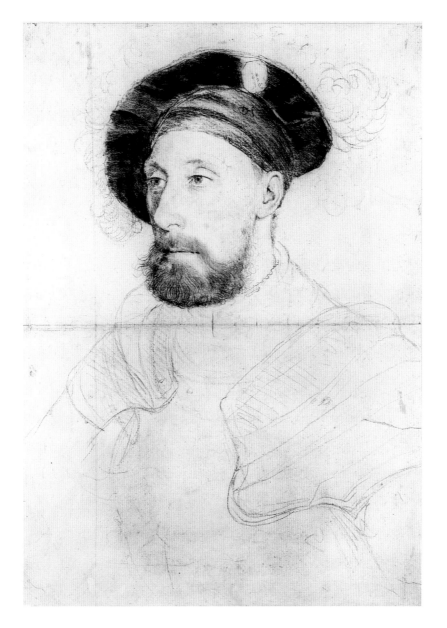

49 *Sir Nicholas Carew*
BASEL, Offentliche Kunstsammlung,
Kupferstichkabinett.
Black and coloured chalks 55 x 38·6 cm.

This drawing is related to the painting at Drumlanrig
Castle (Plate 67), but appears to have been executed
some time before work began on that portrait. The
style of the drawing suggests that it belongs to the
first English period, while the oil painting, which does
not in any case follow the pose of the drawings, must
be later. It therefore seems that the drawing was made
before Holbein left for Basel in 1528, but was never
used for a finished work, and that the painting was
executed on the artist's return to England four
years later.

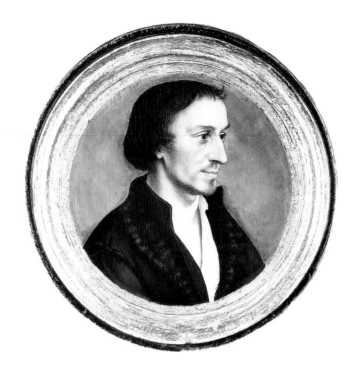

50 *Philip Melanchthon*
HANOVER, Niedersächsische Landesgalerie. c.1530.
Oil on panel 9 cm. (diameter). Inscribed on verso:
QVI CERNIS TANTVM NON VIVA
MELANTHONIS ORA HOLBINVS RARA
DEXTERITATE DEDIT.

This tiny portrait of the German theologian and
reformer is one of the few works by Holbein that can
be dated between his two English visits, c.1530. It is of
a very similar format to roundels of *Erasmus* (Basel,
Offentliche Kunstsammlung) and *Froben* (Merton
collection) also painted about this time and may have
been intended to form part of a group with these
works. Both in format and in the hard modelling of
the facial features this portrait has much in common
with works by Dürer, for instance the portrait of
Johannes Kleberger (Vienna, Kunsthistorisches Museum)
dated 1526.

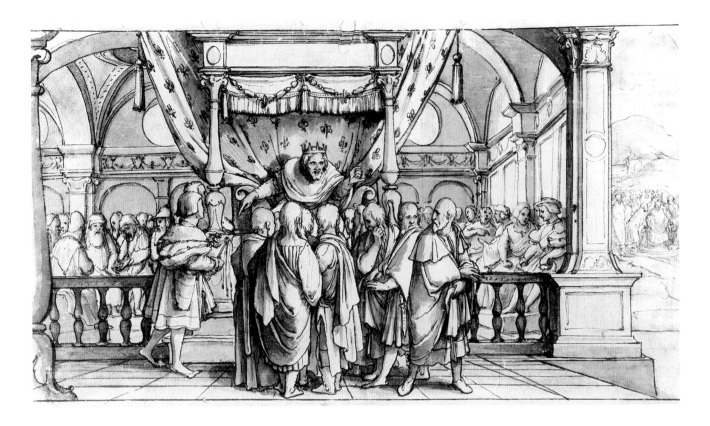

51 *Rehoboam Rebuking the Elders*
BASEL, Offentliche Kunstsammlung,
Kupferstichkabinett. 1530.
Pen and ink with wash and watercolour 22·6 x 38·5 cm.

The composition on the wall of the Great Council Chamber
of the Basel Town Hall, showing Rehoboam rebuking the
elders, was not painted until 1530, in between Holbein's two
English visits. Surviving fragments of the mural (Plate 52)
reveal that when it was painted several changes were made to

this preparatory composition. The story was taken from I
Kings: 12 which recounts how before his accession,
Rehoboam, King of Shechem, consulted both his father's old
councillors and the companions of his youth as to how he
should treat the people. When on the throne he followed the
advice of his young friends, who had recommended
harshness, and rebuked the councillors who had advised
mildness. The overall composition of this design is fairly
similar to that of the *Solomon and the Queen of Sheba* (Plate 85),
to which it is also probably close in date.

52 *Rehoboam Rebuking the Elders*
BASEL, Offentliche Kunstsammlung. 1530.
Fresco 28 x 41.5 cm.

This is one of several fragments of the *Rehoboam* composition
removed from the walls of the Great Council Chamber and
now preserved in the Offentliche Kunstsammlung.

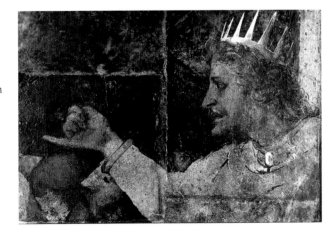

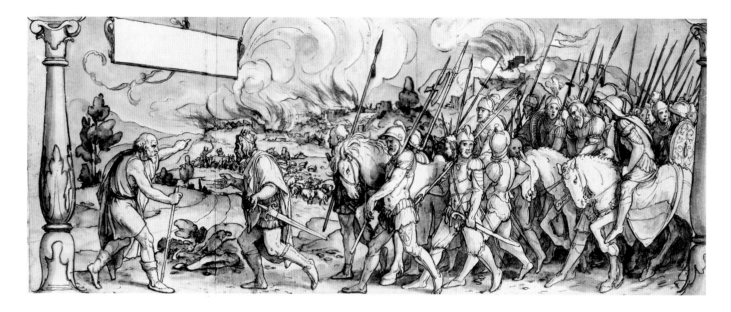

53 *Samuel and Saul*
BASEL, Offentliche Kunstsammlung,
Kupferstichkabinett. c.1530.
Pen and ink with wash and watercolour 21·5 x 53·5 cm.

As with *Rehoboam Rebuking the Elders* (Plate 51), *Samuel and Saul* was not painted in the Great Council Chamber until c.1530. The story was taken from I Samuel: 15.

When Saul conquered the Amalekites at Jehovah's command he did not destroy the whole people as he had been told to do and was therefore dethroned by Samuel. The composition of this design recalls those of Holbein's two *Triumphs* painted in London very shortly afterwards (Plate 62 and see fig. 5); like them, the ultimate source of *Samuel and Saul* was Mantegna's *Triumph of Caesar* series (fig. 3), then in Mantua.

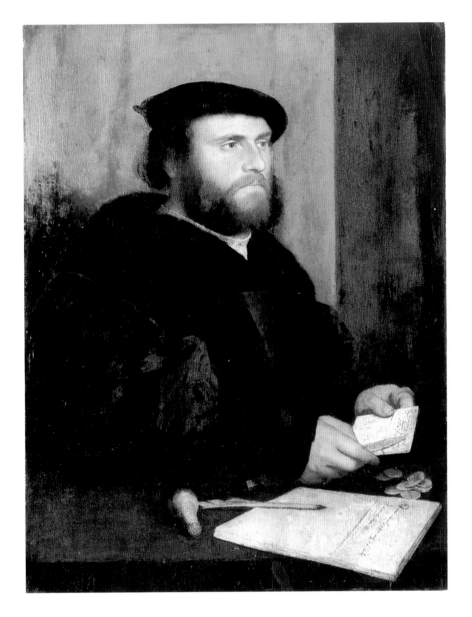

54 *Hans of Antwerp*
WINDSOR CASTLE, Royal Collection. 1532.
Oil on panel 61 x 46.8 cm. Inscribed and dated: Anno
Dns [sic] 1532 auf 26 July Aetatis ...

The sitter in this portrait can almost certainly be
identified as Hans of Antwerp, a member of the
German community in London (Plates 1, 55–58, 60
and 61), who, according to the inscribed tablet on the
table, sat for Holbein on 26 July 1532. If this

identification is correct, it provides the first evidence
of the date of Holbein's return to England, for it was
presumably painted in London. Hans of Antwerp, also
known as John van der Gow, setttled in London in
1513 and between 1537 and 1547 received payments
from the crown for goldsmith's work, including
collaboration with Holbein on various projects for
jewellery and metalwork (Plate 96). Hans of Antwerp
was one of the witnessess to the painter's will in 1543.

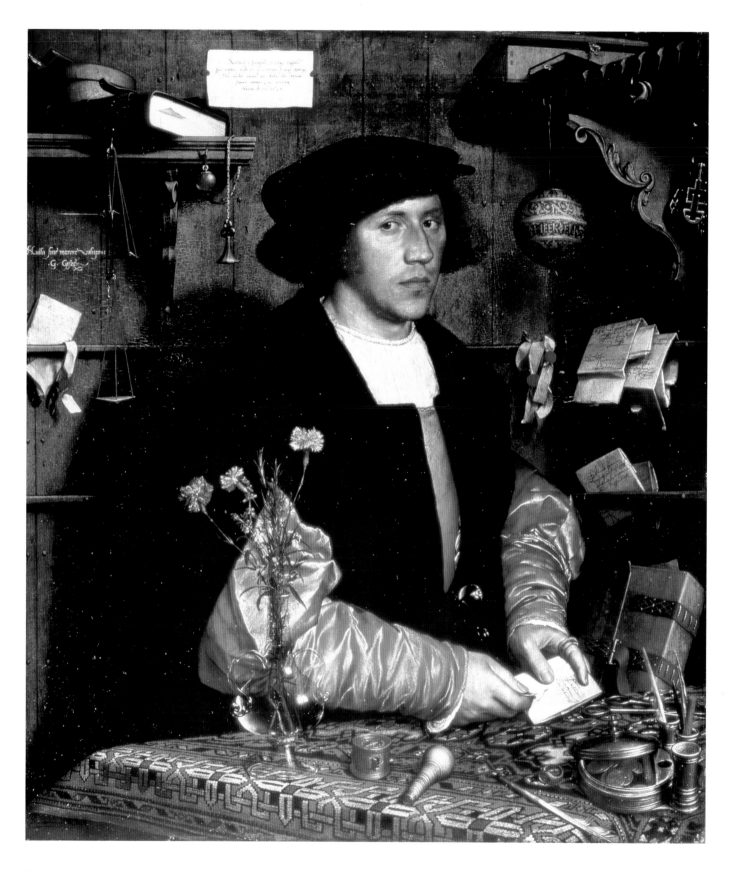

55 *Georg Gisze*

BERLIN, Staatliche Museen, Gemäldegalerie. 1532.
Oil on panel 96·3 x 85·7 cm. Inscribed and dated:
GGISZE; and NVLLA SINE MERORE
VOLVPTAS; and Imagine Georgii Gysenii Ista
refert vultus, qua cernis, Imago Georgi Sic oculo vivos,
sic habet ille genas Anno aetatis suae XXXIIII
Anno dom. 1532.

Georg Gisze was another member of the German
Steelyard and belonged to a family based in Cologne.
This portrait was used as a showpiece for Holbein's
brilliant technique and for the depiction of a wide
variety of different materials.

(above) Detail of Georg Gisze

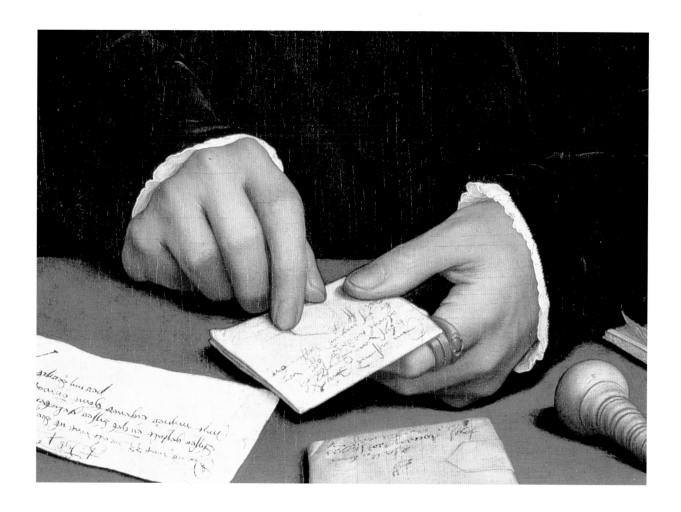

56 *Derich Tybis*
VIENNA, Kunsthistorisches Museum. 1533.
Oil on panel 48 x 35 cm.

The sitter is identified as another member of the German merchant community on inscriptions within the composition. As in the case of *Hillebrandt Wedigh* (Plate 61), Derich Tybis's pose is frontal.

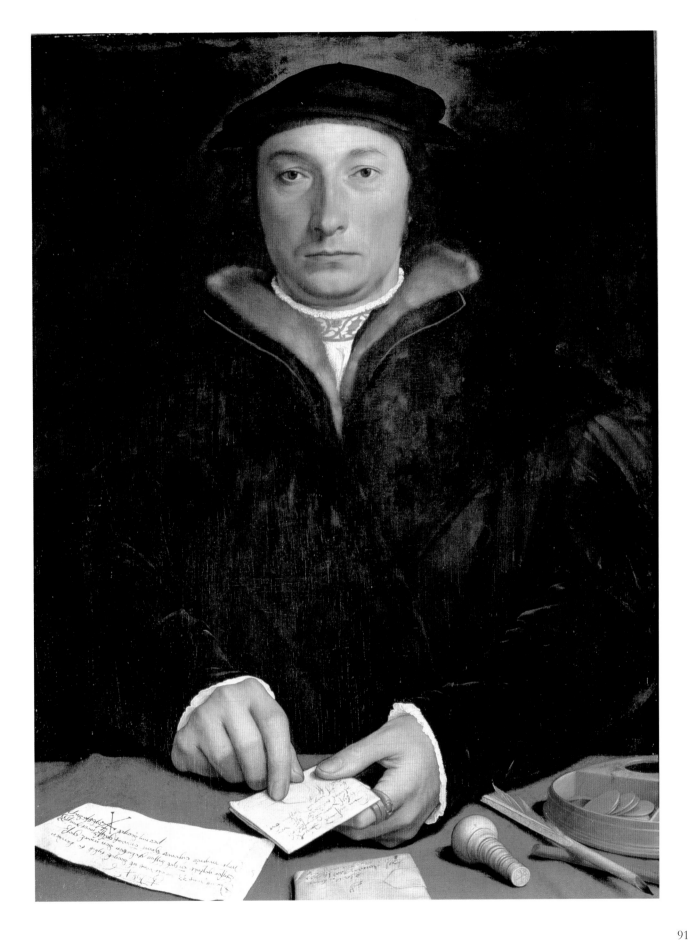

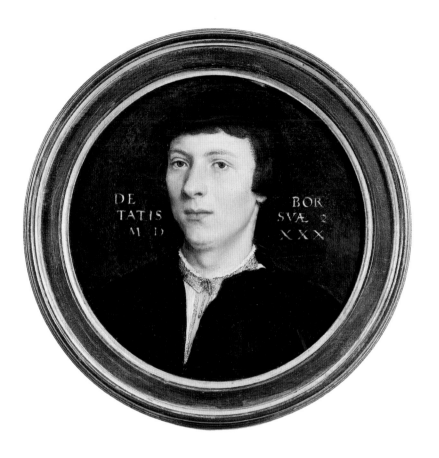

(*opposite*)

57 *Derich Born*

WINDSOR CASTLE, Royal Collection. 1533.
Oil on panel 60·3 x 45 cm. Inscribed: DERICHVS SI
VOCEM ADDAS IPSISSIMVS HIC SIT/HVNC
DVBITES PICTOR FECERIT AN GENITOR;
and DER BORN ETATIS SVAE 23 ANNO 1533.

The sitter was one of several members of the German
Steelyard in London to be portrayed by Holbein
(Plates 54–56 and 60–61) during the months after his
return to England from Basel in 1532. Born, originally
from Cologne, was apparently resident in London
throughout the 1530s and 1540s and in 1536 supplied
war materials for the suppression of the rebellion in
the north, the so-called Pilgrimage of Grace. Another
smaller portrait of him by Holbein, also painted

c.1533, is in the Alte Pinakothek in Munich (Plate 58).
The Windsor portrait is inscribed with the date 1533
and the sitter's age, twenty-three, at the end of an
elegiac couplet which reads in translation: 'Here is
Derich himself; add voice and you might doubt if the
painter or his father created him'.

(*above*)

58 *Derich Born*

MUNICH, Alte Pinakothek.
Watercolour on card applied to panel 10·2 cm.
(diameter). Inscribed and dated (fragmentary): DE
BOR/TATIS SVAE 2/MD XXX.

Born's age appears to be very close to that in the large
painting of him (Plate 57), dated 1533.

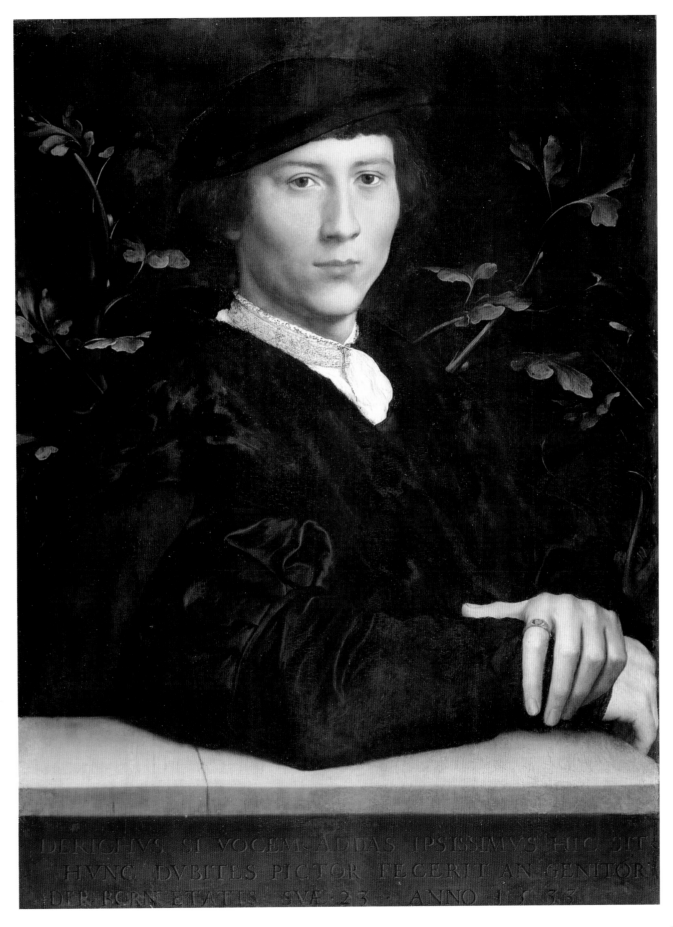

DERICHVS SI VOCEM ADDAS IPSISSIMVS HIC SIT
HVNC DVBITES PICTOR FECERIT AN GENITOR
DER BORN ETATIS SVÆ 23 · ANNO 1533

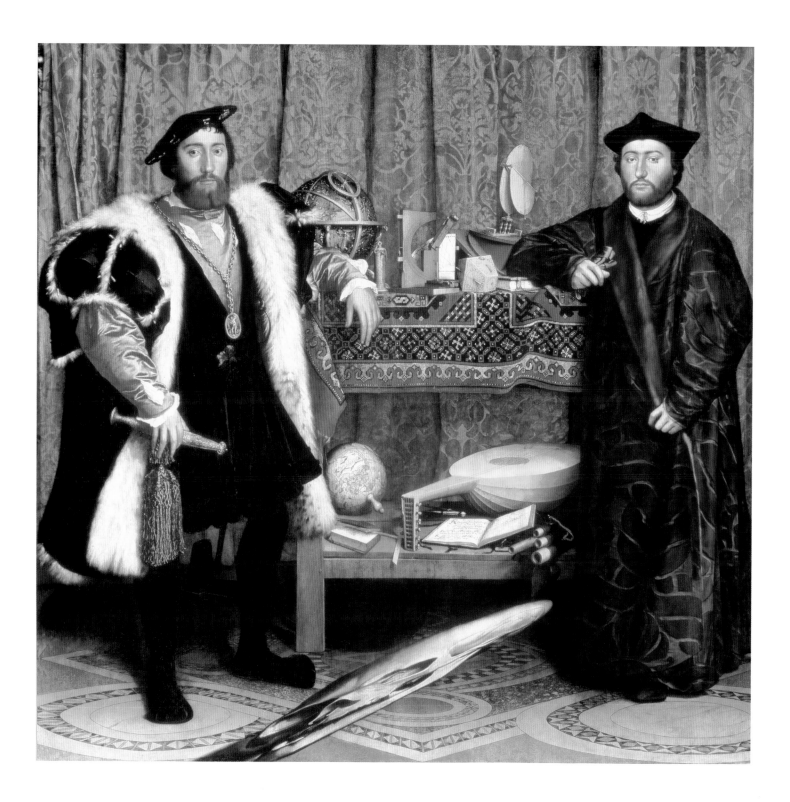

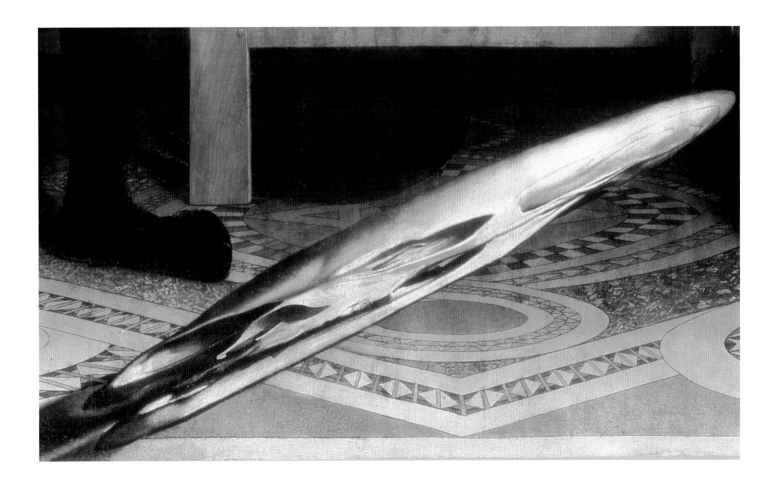

59 *Jean de Dinteville and Georges de Selve* ('*The Ambassadors*')
LONDON, National Gallery. 1533.
Oil on panel 207 x 209·5 cm. Signed and dated: 1533; inscribed with the sitters' ages [twenty-nine and twenty-five respectively].

This magnificent double portrait represents the French ambassador to London, Jean de Dinteville, seigneur de Polisy, with his friend Georges de Selve, Bishop of Lavaur, who visited him in London in 1533, at the time this portrait was painted. The exact date of the painting, 11 April 1533, can be worked out from the various instruments on the buffet between the two sitters. There are many other points of interest in this picture, including the pavement, which is a virtual copy of that in the sanctuary of Westminster Abbey, and the curiously foreshortened skull in the foreground, which is one of many *vanitas* symbols in the painting. The contents of the open books can still be easily read: one is a hymn book and the other a book of arithmetic. The terrestrial globe is marked with several additional locations in France, including Polisy, which would have been relevant to the sitters. Our understanding of this picture has been greatly aided by the exposition of it by Mary Hervey published in 1900.

(above) Detail of Jean de Dinteville and Georges de Selve ('The Ambassadors').

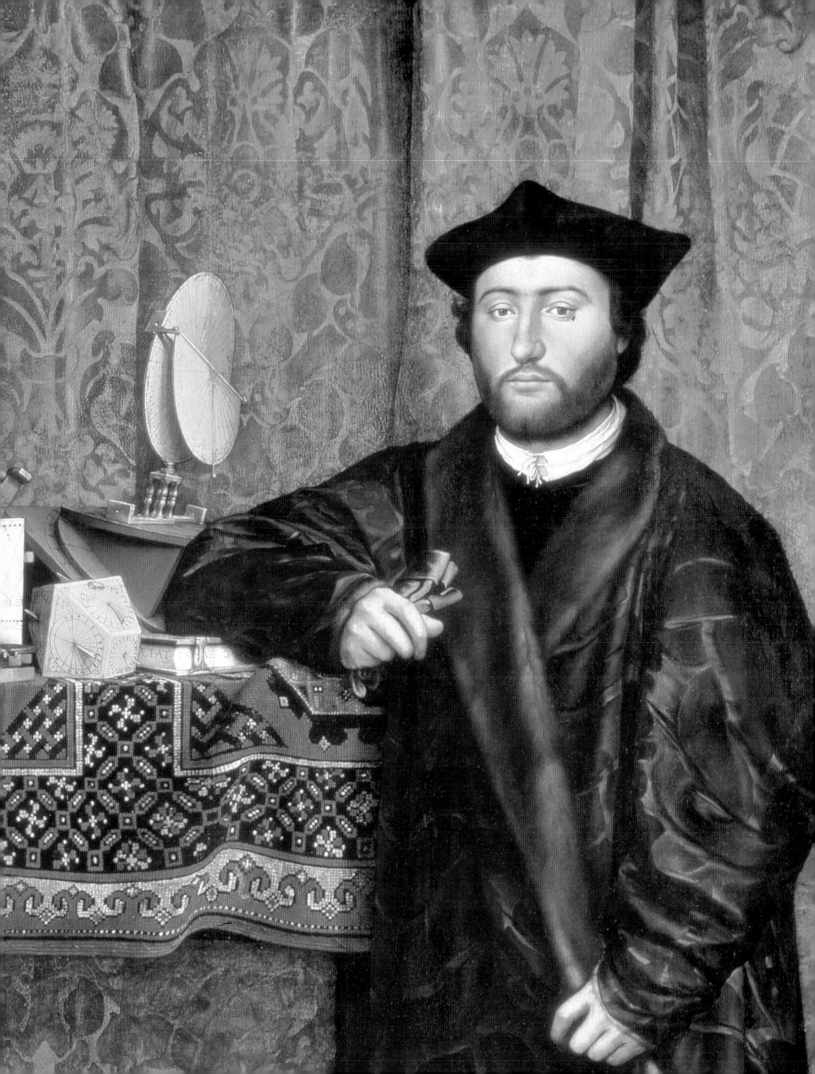

(above and left)
Detail of Jean de Dinteville and Georges de Selve ('The Ambassadors'), Plate 59.

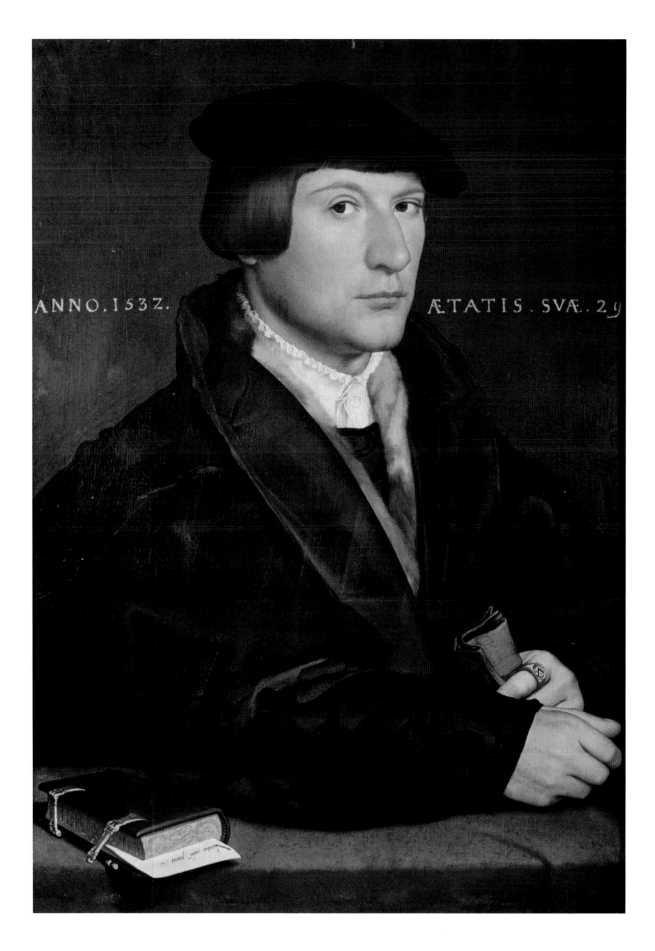

ANNO.1532. ÆTATIS.SVÆ.29

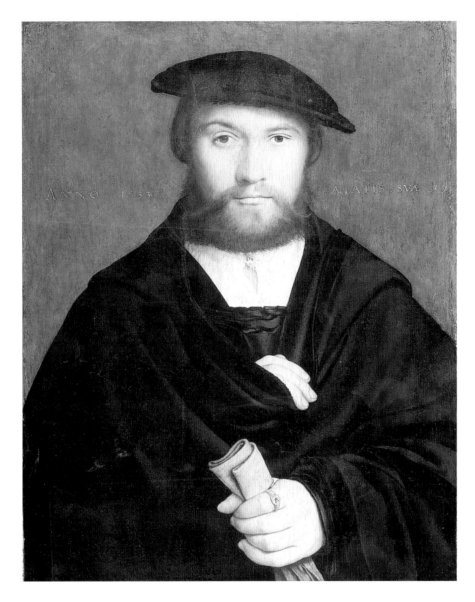

60 *A Member of the Wedigh Family (left)*
NEW YORK, Metropolitan Museum of Art (bequest of
Edward S. Harkness). 1532.
Oil on panel 41·9 x 31·8 cm. Signed with monogram
and inscribed and dated: ANNO 1532. AETATIS
SVAE 26; and HER. WID.

The arms of the Wedigh family of Cologne are on the
sitter's signet ring; several members of the family,
Hillebrandt Wedigh (Plate 61), for instance, belonged
to the German Steelyard in London for which Holbein
did much work in the early 1530s.

61 *Hillebrandt Wedigh (above)*
BERLIN, Staatliche Museen, Gemäldegalerie. 1533.
Oil on panel 39 x 30 cm. Inscribed and dated: ANNO
1533 AETATIS SVAE 39.

The sitter is shown in an unusual frontal pose rarely
used in portraiture, but seen in Dürer's *Self-portrait* of
1500 (Munich, Alte Pinakothek) and later in Holbein's
royal portraits, for instance those of *Christina of
Denmark* (Plate 68), *Anne of Cleves* (Plate 77), and
Edward, Prince of Wales (Plate 78).

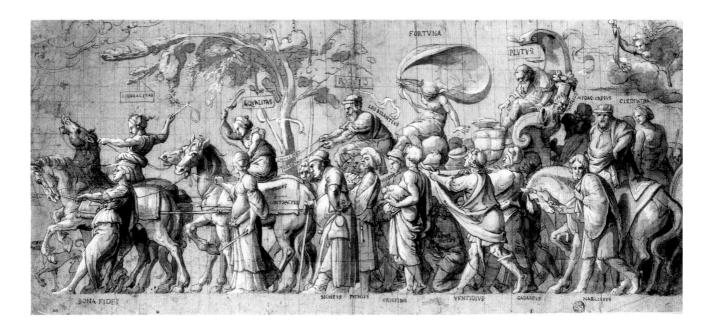

62 *The Triumph of Riches (above)*
PARIS, Musée du Louvre, Cabinet des Dessins.
Pen and wash heightened with white 25 x 56·9 cm.

This is Holbein's finished design for one of the two *Triumphs* painted for the Guildhall of the German Steelyard, c.1532–33 (see also fig. 5). Not all the figures are identified in this drawing but the names are given on later copies. The procession is centred around Plutus, who is bowed down by the burden of rich living, with his feet resting on a sack of gold, and who is seated in a magnificent chariot drawn by four white horses. Blindfolded Fortune sits immediately in front of him and scatters gold among the crowd while Ratio holds the two reins, labelled Notitia and Voluntas, which guide the horses. The horses are entitled Impostura, Contractus, Avaritia and Usura and are led by fine women called Bona Fides, Iustitia, Liberalitas and Aequalitas. This central group is surrounded by many of the famous men of fortune recorded in

antiquity, while Croesus rides behind and Nemesis hovers above them all in the clouds. The meaning of this scene is clear: the instability of fortune and glory and the dangers of undue arrogance in prosperity. Such sentiments were complemented by those in *The Triumph of Poverty*, which is now known only through later copies (fig. 5).

63 *Parnassus (right)*
BERLIN, Staatliche Museen, Kupferstichkabinett. 1533.
Pen and black ink and watercolour on brown prepared paper 42·1 x 38·4 cm.

The content of this drawing showing Apollo and the Muses, as if on Parnassus, raised above a triumphal arch, connects it with the form of the triumphal arch erected by the German community in London for Queen Anne Boleyn's coronation procession on 31 May 1533.

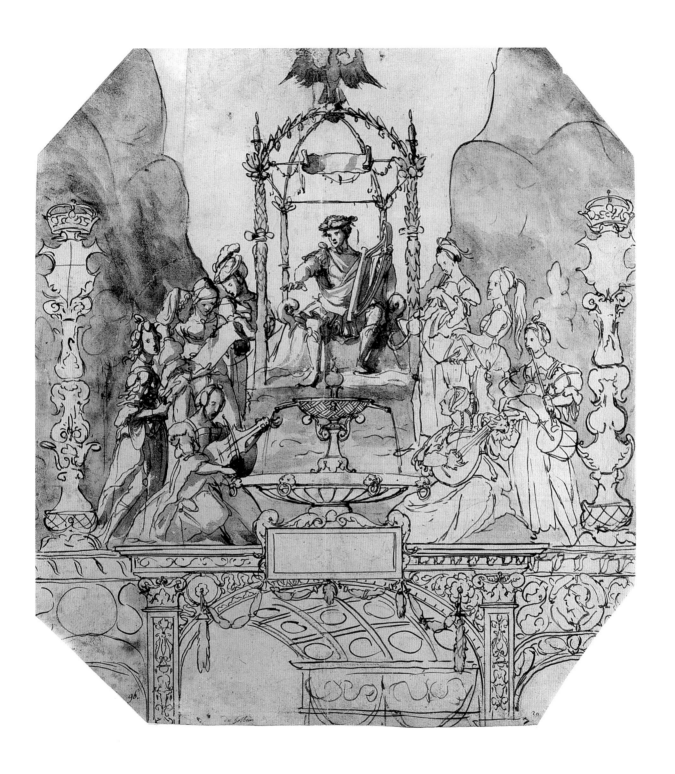

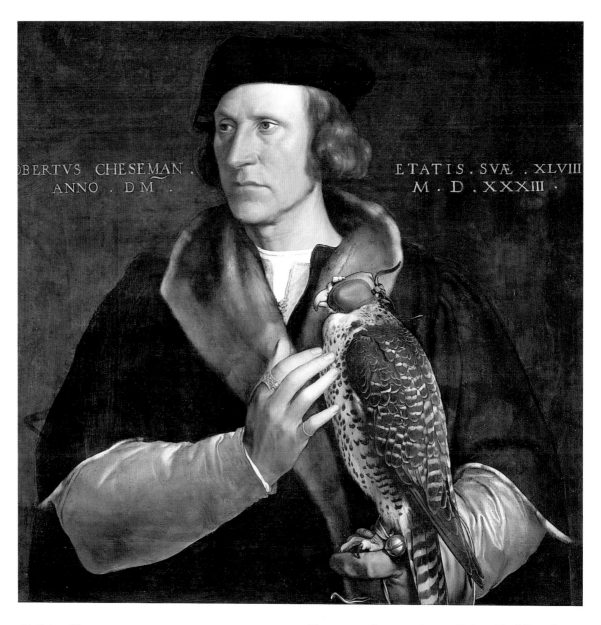

64 Robert Cheseman
THE HAGUE, Mauritshuis. 1533.
Oil on panel 59 x 62·5 cm. Inscribed and dated:
ROBERTVS CHESEMAN.
ETATIS.SVAE.XLVIII.ANNO DM.M.D.XXXIII.

Cheseman, who came from a distinguished line of landed gentry, is here shown holding a hooded hawk on his gloved hand. The oblong format of this portrait is unusual and very striking.

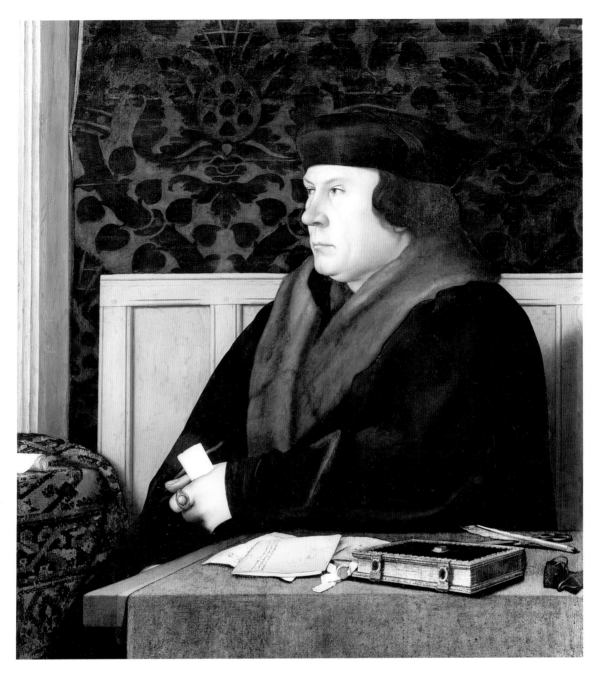

65 *Thomas Cromwell*
NEW YORK, Frick Collection. 1533.
Oil on panel 76 x 61 cm.

The date of this portrait, which is the best of several versions of a lost original by Holbein, is determined on the basis of the letter on the table in front of Cromwell, addressed by the King 'to our trusty and right well beloved counsillor Thomas Cromwell, Master of our Jewelhouse', to which office Cromwell was appointed in 1533. The commission to paint Cromwell may have been Holbein's stepping stone to employment by the court. Cromwell rose from humble origins in Putney to high royal favour during the 1520s, and by the time of Holbein's return to England in 1532 he had become a privy councillor. In 1533 he became Chancellor of the Exchequer and then the King's Secretary and Master of the Rolls. In 1540 he was, however, indicted for treason and executed, as he was regarded as the chief advocate of a Protestant policy and of Henry VIII's marriage to Anne of Cleves (Plate 77).

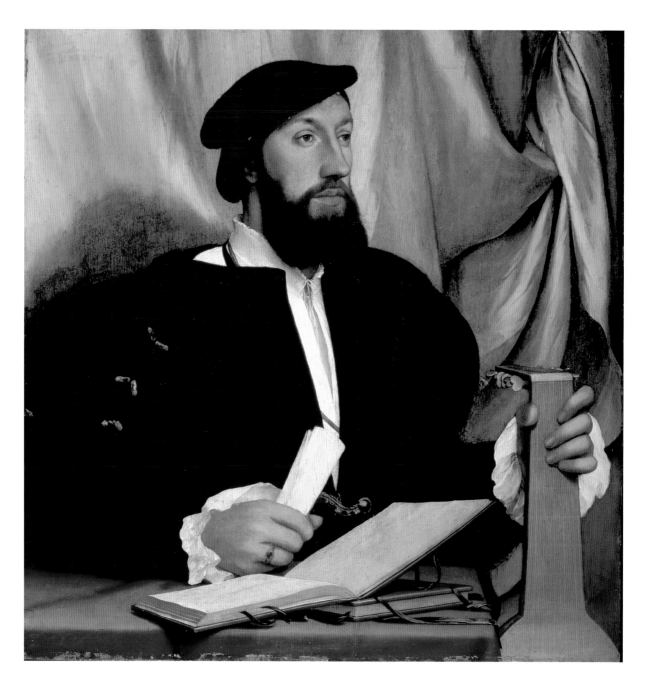

66 *Unknown Man with a Lute*
BERLIN, Staatliche Museen, Gemäldegalerie.
Oil on panel 43·5 x 43·5 cm.

The man here portrayed was presumably a musician at
the English court, for the painting is similar in style to
pictures dated c.1535–36, for instance the portrait of
Richard Southwell (Plate 75).

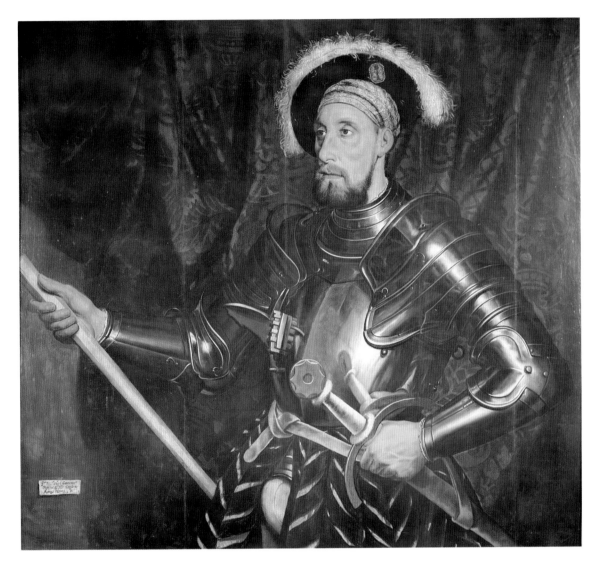

67 *Sir Nicholas Carew*
DRUMLANRIG CASTLE, DUMFRIESSHIRE, collection of
the Duke of Buccleuch.
Oil on panel 91·3 x 101·7 cm. Inscribed (at a later
date): Sir Nicholas Carewe Master of the Horse to
King Henry y 8.

This striking portrait has caused problems in dating for
while the preparatory drawing for the head at Basel
(Plate 49) is in black and coloured chalks, as are the
studies from Holbein's first English period, the format

of the painted portrait can be connected with others,
for instance, that of the *Sieur de Morette* (Plate 71)
executed during the 1530s, at the time of Holbein's
return to England. The drawing was followed by the
painting only so far as the head was concerned, and the
stance of the figure was altered to a much bolder and
more angular pose. It therefore seems that Carew may
have sat to Holbein at the end of the first visit, and
that the painting was not executed until the artist's
return to England about four years later.

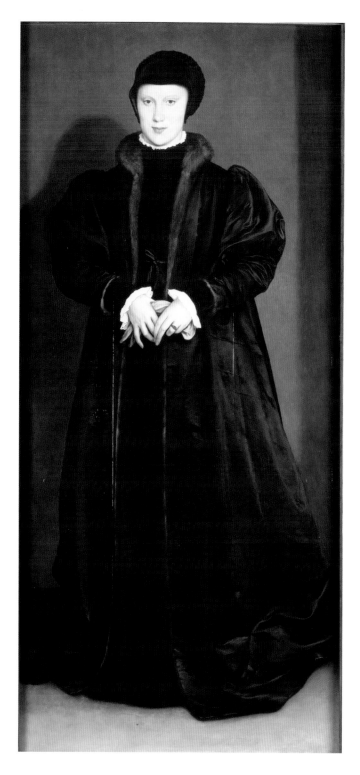

68 *Christina of Denmark, Duchess of Milan*
LONDON, National Gallery. 1538.
Oil on panel 179 x 82·5 cm.

Christina of Denmark, daughter of Christian II, deposed King of Denmark, niece of Charles V, Holy Roman Emperor, and widow of Francesco Maria Sforza, Duke of Milan, hence her mourning dress, was one of the many princesses whose hand was sought in marriage by Henry VIII following the death of Queen Jane Seymour in 1537. Negotiations for the match continued throughout 1538 and part of 1539, at which time Christina was living at the court of her aunt, Mary of Hungary, Regent of the Netherlands, in Brussels. Holbein was sent to Brussels to paint her in the spring of 1538 and on 12 March Christina sat to the painter for 'thre owers space'; the English ambassador to Brussels considered the result 'very perffight'. The study made at this one sitting was presumably either a drawing or a painting on paper or parchment, as was the case with the portrait of *Anne of Cleves* (Plate 77) which Holbein executed in 1539; in such a form it could be easily transported back to England. The likeness made in Brussels was shown to Henry VIII in England on 18 March and 'singularly pleased the King, so much so, that since he saw it he has been in much better humor than he ever was making musicians play on their instruments all day long'. However, the negotiations fell through and in 1541 Christina, a renowned beauty, married François, duc de Bar, the future Duke of Lorraine, as her second husband.

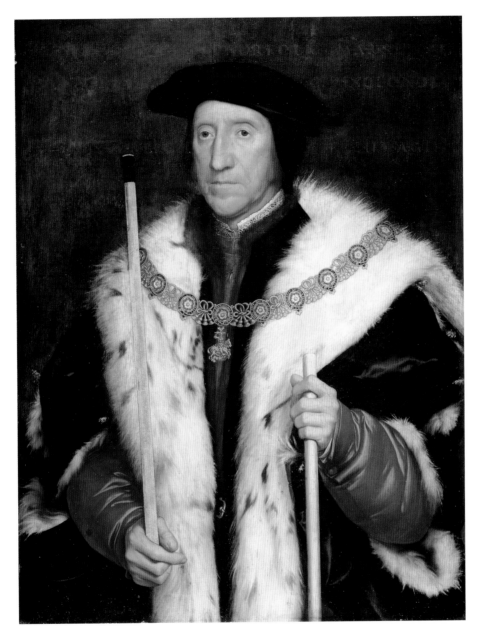

69 *Thomas Howard, third Duke of Norfolk*
WINDSOR CASTLE, Royal Collection. 1539.
Oil on panel 80·3 x 61·6 cm.

In the inscription, only dimly visible today beneath
layers of overpaint, the sitter is identified as the Duke
of Norfolk and is said to be shown in his sixty-sixth
year, which would mean that the portrait was painted
in 1539. Norfolk is depicted clasping the white wand
of Lord Treasurer and the gold baton of Earl Marshal,

offices he occupied from 1522 and 1533 to 1547
respectively. He was closely connected to the throne,
for his first wife was a daughter of King Edward IV,
and he was uncle to both Anne Boleyn and Catherine
Howard, godfather to Prince Edward and father-in-law
to Henry Fitzroy, illegitimate son of Henry VIII.
However, in 1547 he was charged with high treason
and attainted; he remained in prison under Edward VI
but was fully restored by Queen Mary I.

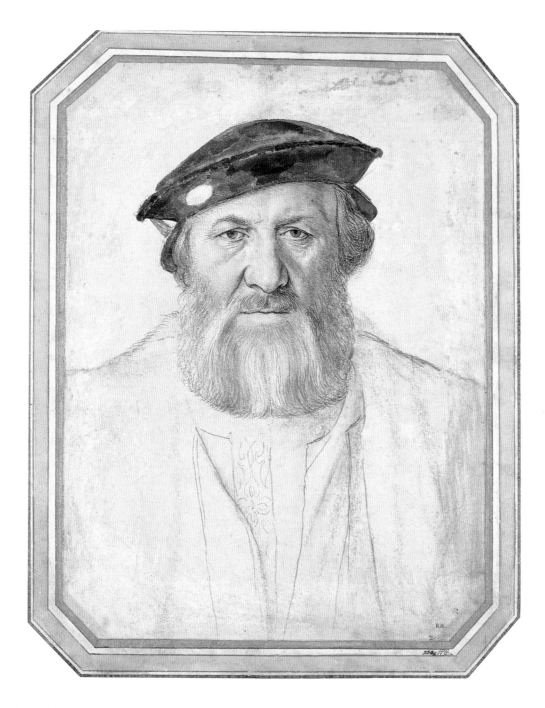

70 *Charles de Solier, Sieur de Morette*
DRESDEN, Staatliche Gemäldegalerie,
Kupferstichkabinett. 1534–35.
Black and coloured chalks and ink applied with pen
and brush on pink prepared paper 33 x 24·3 cm.

The sitter was resident in England as French
ambassador from 1534 to 1535. The brilliantly
depicted facial features of the drawing were slightly
modified for the painting, which relies for its effect
instead on the overall mass of the sitter, with his
thickly padded sleeves and jacket, placed in front of
the richly patterned curtains.

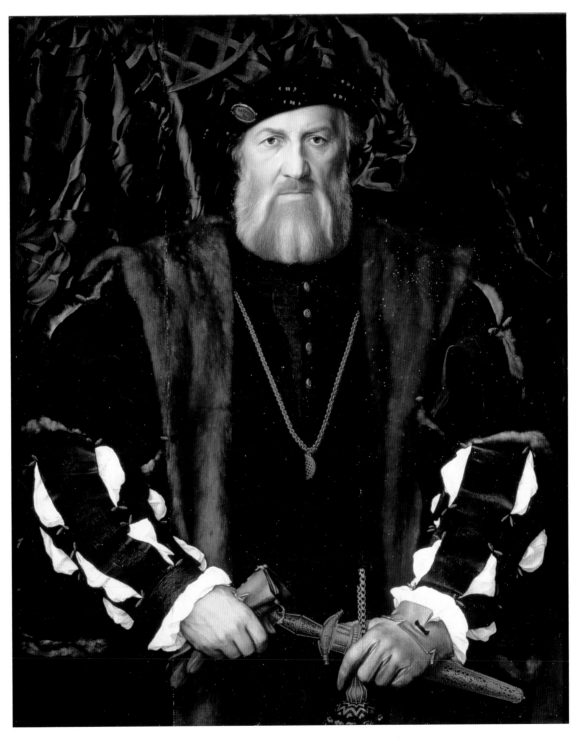

71 *Charles de Solier, Sieur de Morette*
DRESDEN, Staatliche Gemäldegalerie. 1534–35.
Oil on panel 92·5 x 78 cm.

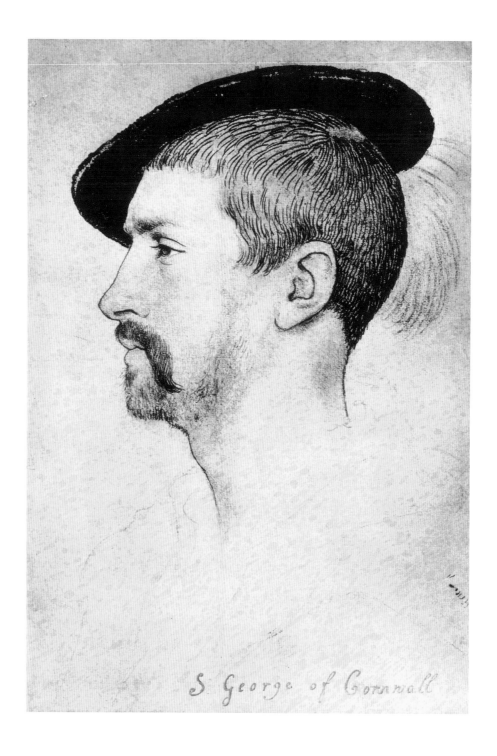

72 *Simon George*
WINDSOR CASTLE, Royal Library.
Black and coloured chalks and black ink applied with pen and brush on pink prepared paper 28·1 x 19·3 cm.

The painting (Plate 73) repeats the drawing in all essentials, but shows the sitter fully bearded. Little is known about Simon George except that he came from a Dorset family and settled at Quotoule in Cornwall.

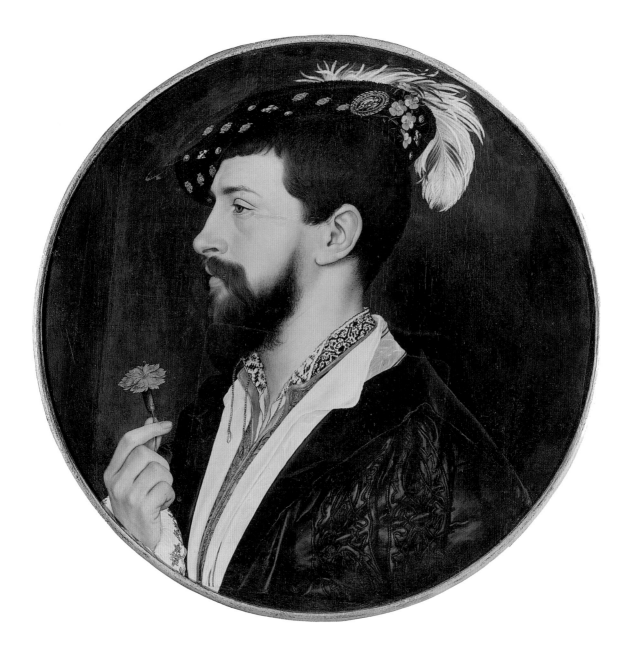

73 *Simon George*
FRANKFURT, Städelsches Kunstinstitut.
Oil on panel 31 cm. (diameter).

74 *Unknown Man*
VIENNA, Kunsthistorisches Museum. 1541.
Oil on panel 47 x 35 cm. Inscribed and dated:
ANNO.DNI.1541 ETATIS SAVE 28.

The identity of the sitter is unknown but the date
inscribed across the background establishes that he
was resident in England. His pose is a curious
amalgam of those of the two members of the Wedigh
family (Plates 60 and 61), whose portraits Holbein had
painted about ten years earlier.

75 *Sir Richard Southwell*
FLORENCE, Galleria degli Uffizi. 1536.
Oil on panel 47·5 x 38 cm. Inscribed and dated: X°
IVLII ANNO H.VIII XXVIII° ETATIS
SVAE.ANNO XXXIII.

From the inscription, which states that the portrait was painted in the twenty-eighth year of Henry VIII's reign, we can calculate its date as 1536. At that time Southwell was acting as an agent for Thomas Cromwell in the dissolution of the monasteries; he was at various times Sheriff and Member of Parliament for Norfolk and was knighted in 1542. The preparatory study for this portrait is at Windsor both the drawing and the painting are meticulous in showing the scars on Southwell's forehead and neck, which, in the case of the drawing, were formerly thought to be old repairs in the paper. The drawing is annotated: 'the eyes a little yellowish'. This painting was given by Thomas Howard, second Earl of Arundel, the great connoisseur and collector, who had a particular interest in Holbein, to Cosimo II, Grand Duke of Tuscany.

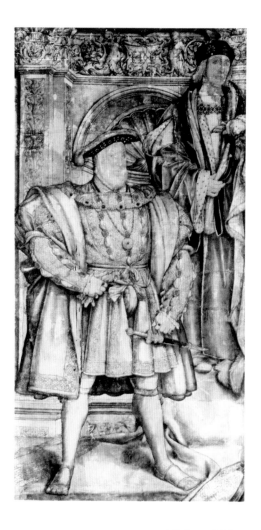

76 *King Henry VIII*
LONDON, National Portrait Gallery. c.1536–37.
Black ink and watercolour washes on paper mounted
on canvas 257·8 x 137·1 cm.

This is part of Holbein's original cartoon for his wall
painting in the Privy Chamber of Whitehall Palace,
executed c.1536–37. Although the painting was
destroyed in 1698 it is known from copies by
Leemput (fig. 9). The creation of the magnificent,
even overwhelming, image of the King was one of
Holbein's great achievements during his stay in
England; the contrast between Henry VIII in the
foreground and the graceful but almost slight figure
of his father, Henry VII, behind is especially marked.
The cartoon for the King's head, which is close to
that in the Thyssen portrait (Plate 82), is on a separate
sheet of paper, cut out and stuck onto the whole.

77 *Anne of Cleves*
PARIS, Musée du Louvre. 1539.
Tempera on parchment worked over in oil and laid
down on panel 65 x 48 cm.

The circumstances surrounding the painting of the
portrait of *Anne of Cleves* were similar to those for
Christina of Denmark (Plate 68). Holbein was sent to
Düren to paint the two sisters of the Duke of Cleves
in June 1539. The unusual technique of the Louvre
portrait was probably determined by the need to
transport it easily back to England. Henry VIII was
evidently sufficiently satisfied with Anne's appearance
to agree to the marriage scheme, and in January 1540
he married her. However, the union lasted only six
months as the King came to be repulsed by his
consort, 'the Flanders mare', and following the
divorce she lived with her own court at Richmond.

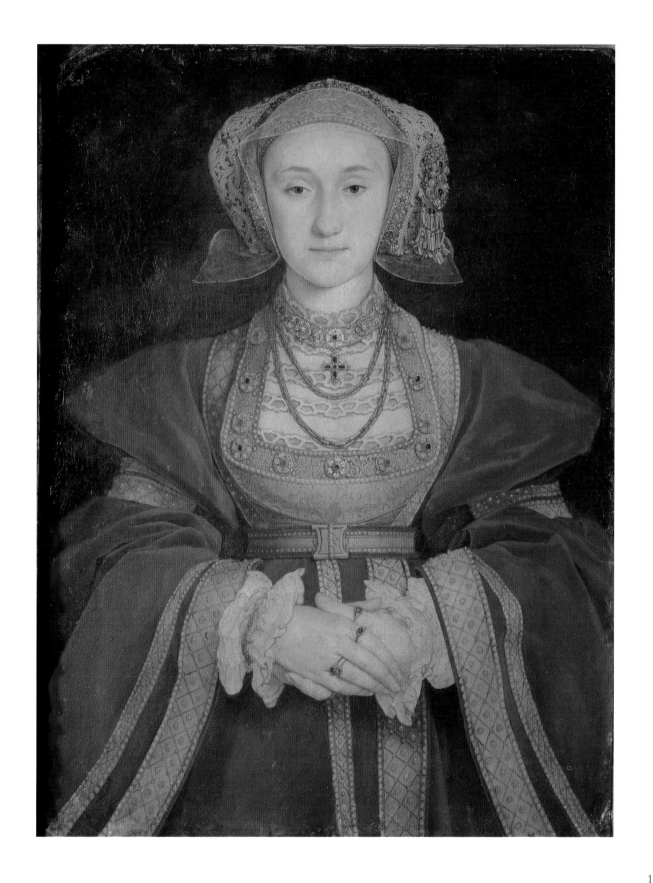

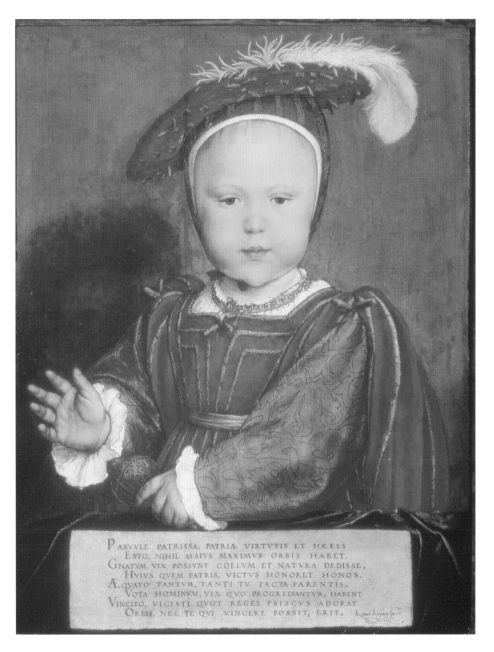

78 *Edward, Prince of Wales*
WASHINGTON, National Gallery of Art (Andrew
Mellon collection). 1539.
Oil on panel 57 x 44 cm.

This picture is normally identified with the gift
presented to the King by the artist on New Year's Day
1540: 'By Hanse Holbeyne a Table of the pictour of
the prince [prince's] grace'. Below the portrait are Latin
distychs composed by the court poet Richard Morysin,
encouraging the prince to surpass his father's
achievements.

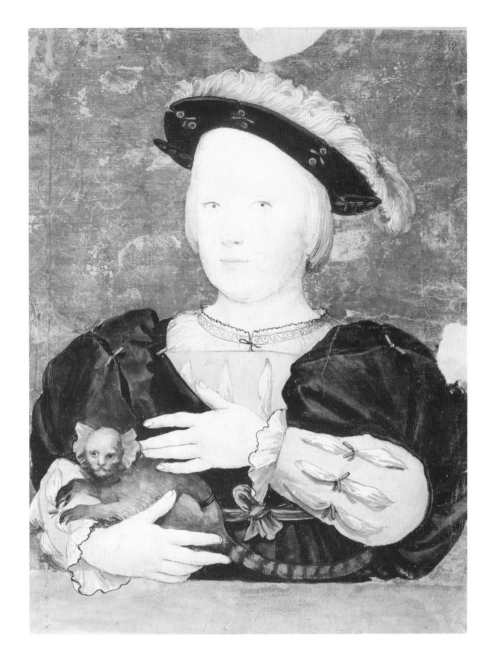

79 *Edward, Prince of Wales, with a Monkey*
BASEL, Offentliche Kunstsammlung,
Kupferstichkabinett. c.1543.
Black and coloured chalks with ink applied with brush
and watercolour 40·1 x 30·9 cm.

This curious drawing must have been executed in
Holbein's last years and therefore provides a good
example of the recurrence of similar techniques at
widely separated intervals throughout his career; in
many respects it is very similar to the drawing of *John
Godsalve* at Windsor (Plate 40), which is datable to
c.1528

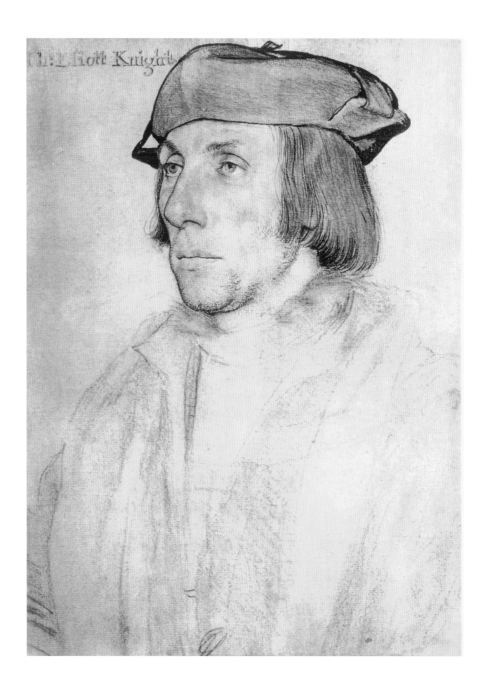

80 *Sir Thomas Elyot*
WINDSOR CASTLE, Royal Library.
Black and coloured chalks reinforced with black ink and
body colour on pink prepared paper 28·6 x 20·6 cm.

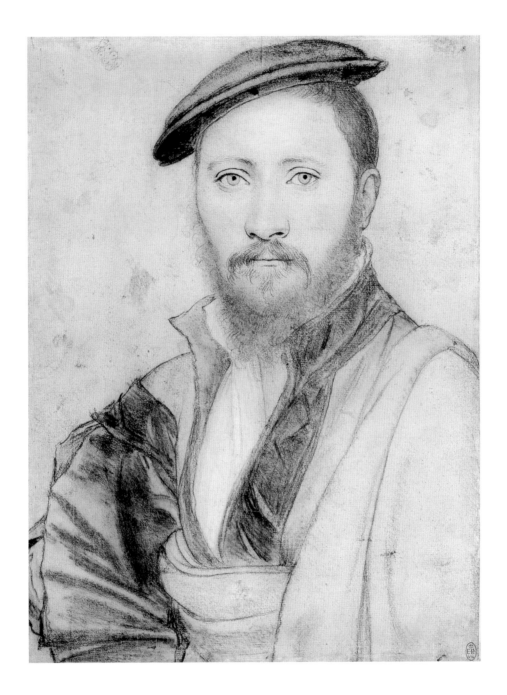

81 *Unknown Man*
WINDSOR CASTLE, Royal Library.
Black and coloured chalks and black ink on pink
prepared paper 29·8 x 22·2 cm.

Although the identity of the sitter is unknown, the
date of the drawing can be ascertained on the basis of
its connection with the small circular oil painting in the
Metropolitan Museum of Art, New York, which gives
the sitter's age as twenty-eight and the date as 1535.
The drawing has evidently been trimmed on both sides
and at the bottom, for the miniature includes the
sitter's hands and other features missing from the
drawing.

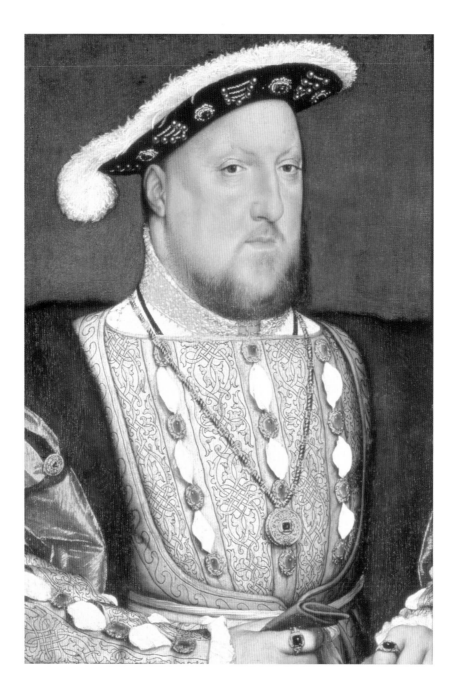

82 *King Henry VIII*
MADRID, Museo Thyssen-Bornemisza. 1536–37.
Oil and tempera on panel 27·5 x 19·5 cm.

This is probably the only surviving panel painting of
the King by Holbein which is entirely autograph. The
King's appearance and pose are closely connected with
those in the Whitehall cartoon (Plate 76) painted
c.1536–37. The Thyssen portrait may be one side of a
diptych with portraits of King Henry VIII and Queen

Jane Seymour which was recorded in the royal
inventories of 1542 and 1547. The gold thread of the
fabric, the embroidery around the shirt neck and the
gold in the chain and jewellery were all painted with
real gold, as they were in the portrait of *Edward, Prince
of Wales* (Plate 78). The King's face is depicted with a
flatness typical of Holbein's royal portraits; it is easy to
overlook the modelling in the lower part of the panel
and in particular in the right hand.

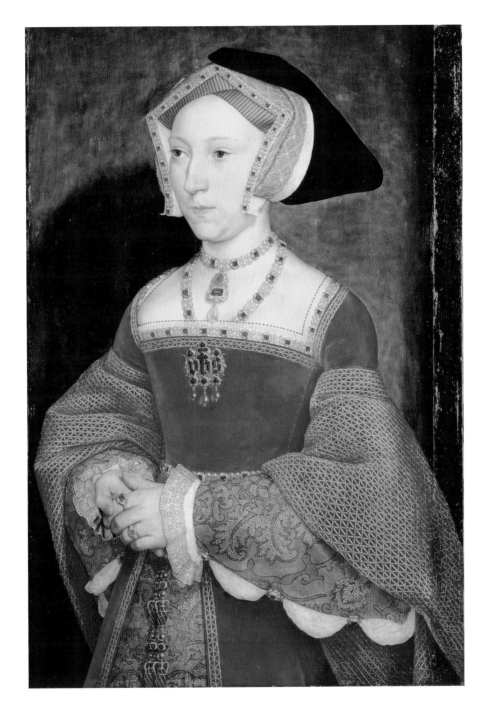

83 *Queen Jane Seymour*
VIENNA, Kunsthistoriches Museum. 1536–37.
Oil on panel 65 x 40·5 cm.

Jane Seymour was lady-in-waiting to both Queen Catherine of Aragon and Queen Anne Boleyn before marrying Henry VIII as his third wife in 1536, the day after Queen Anne's execution. In 1537 she bore a son, the future King Edward VI (Plates 78 and 79) but died two days after his birth. The pose in which Queen Jane is here portrayed is similar to that in the preparatory study at Windsor and in the Whitehall mural (see fig. 9), with which this painting must be contemporary. There are several other versions of this portrait the best of which is the small panel in the Mauritshuis, The Hague.

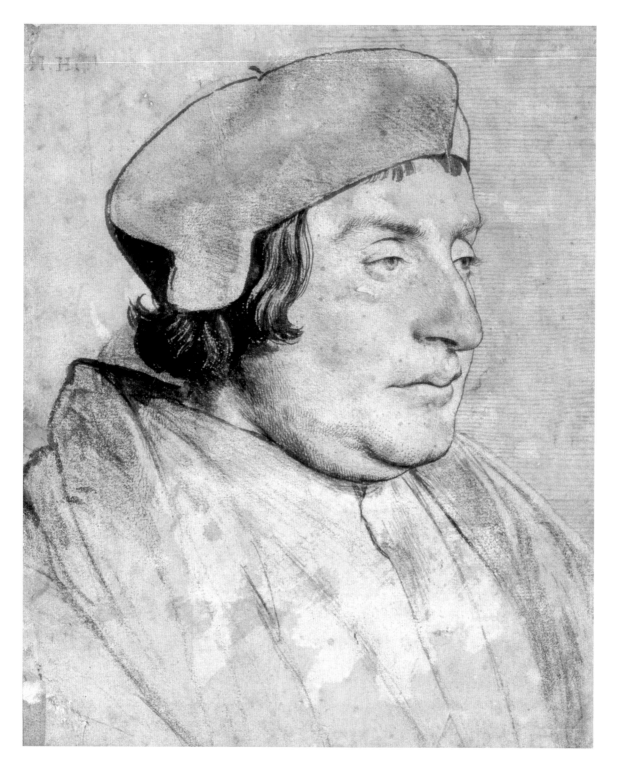

84 *Scholar or Cleric*
BAKEWELL, Chatsworth House,
Devonshire collection.
Point of brush and black ink over black chalk on pink
prepared paper 21·7 x 18·4 cm. Inscribed: HH.

This drawing probably dates from early in Holbein's
second English period.

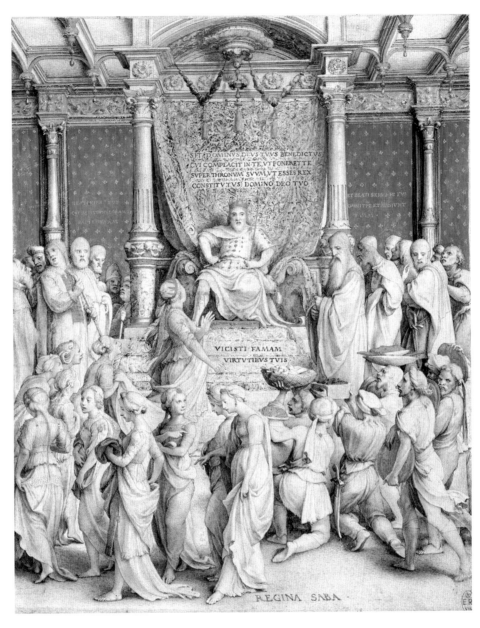

85 *Solomon and the Queen of Sheba*
WINDSOR CASTLE, Royal Library.
Ink applied with pen and brush, watercolour, body
colour and gold paint 22·7 x 18·3 cm. Inscribed.

The role of Solomon was adopted by Henry VIII in
this miniature painting, and as we know that the King
was bearded as early as 1519 it is now no longer
necessary to date this work to c.1535, as was previously
thought. Indeed the rather elongated forms of the
figures, moving in graceful lines across the foreground,
suggest a date late in Holbein's first English period
rather than early in his second. This would, of course,
presuppose Holbein's entering royal service

considerably before he is documented as having
worked for the King. The miniature was probably
intended as a presentation piece like the Washington
portrait of *Edward, Prince of Wales* (Plate 78) which was
probably given to the King by the artist on New Year's
Day, 1540. Although the scale and context of this
painting are unique in Holbein's *oeuvre*, it is possible to
find points of compositional similarity with other
works, especially decorative schemes, for instance
Rehoboam Rebuking the Elders (Plates 51 and 52) which
would have been executed shortly after this miniature.
The architecture is also fairly close to that in the
Whitehall mural.

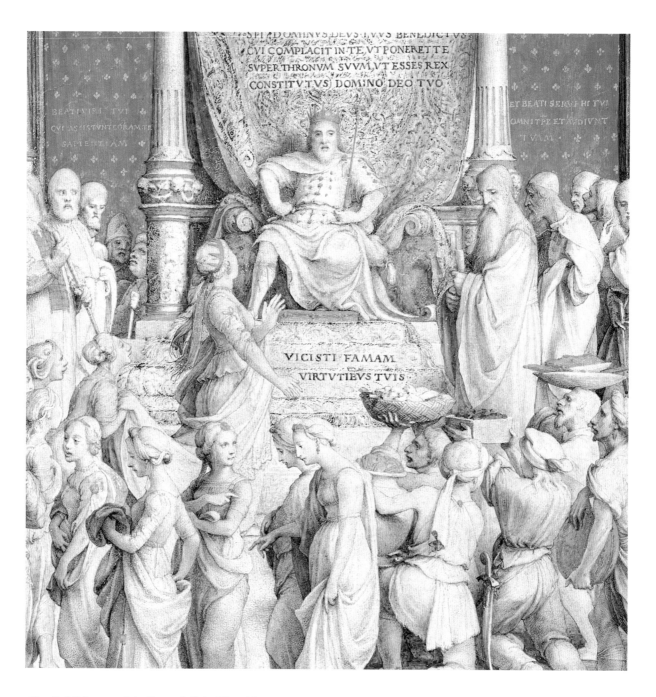

Detail of Solomon and the Queen of Sheba, Plate 85.

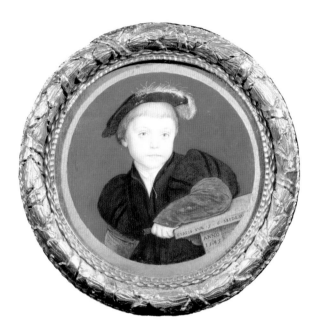

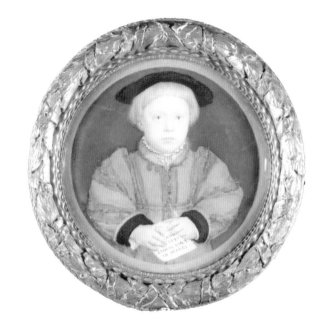

86 *Henry Brandon, second Duke of Suffolk*
WINDSOR CASTLE, Royal Collection. 1541.
Tempera on vellum applied to a playing card
5·6 cm. (diameter). Inscribed and date:
etatis.sue.5.6.sepdem./ANNO 1535.

87 *Charles Brandon, third Duke of Suffolk*
WINDSOR CASTLE, Royal Collection. 1541.
Tempera on vellum applied to a playing card
5·5 cm. (diameter). Inscribed and dated:
ANN/1541/ETATIS SVAE 3/10.MARCI.

These miniatures appear to have been painted
as pendants in 1541, so that the date on the
portrait of the second duke must record the
elder boy's birth rather than the date of the
miniature's execution. These miniatures were in
the collection of King Charles I, when they
were stated to have been 'Don by Hanc
Holben'. Their exquisite techniques confirms
this attribution. The Brandon boys were closely
connected to the court: they were the sons of
the fourth marriage of Henry VIII's trusted
friend and devoted servant, Charles Brandon,
first Duke of Suffolk, whose third wife had
been the king's own sister, Mary Tudor, the
dowager Queen of France. This meant that the
Brandon boys' half-sisters, Frances and Eleanor
Brandon, were nieces to Henry VIII and first
cousins and, in some eyes, heiresses to Edward
VI, with whom Henry Brandon (Plate 86) was
educated and at whose coronation he carried
the Orb. Both Henry and Charles Brandon
attended St John's College, Cambridge, and
were renowned for their learning; they died of
the sweating sickness within half an hour of
each other in 1551.

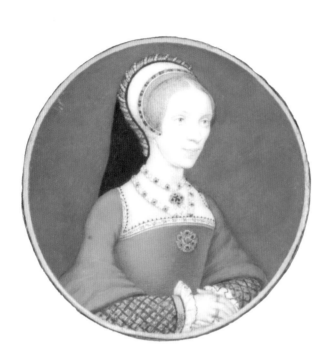

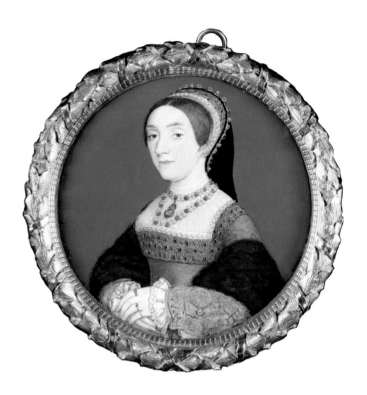

88 *Lady Audley*
WINDSOR CASTLE, Royal Collection.
Tempera on vellum applied to a playing card
5·6 cm. (diameter).

This likeness is connected with that shown in one of
Holbein's drawings, also in the Royal Collection,
inscribed 'The Lady Audley'. There were two families
called Audley at court and it is probable that the lady
portrayed in this miniature was Elizabeth, the daughter
of the second Marquess of Dorset, who married the
Lord Chancellor, Lord Audley of Walden, in 1538 as
his second wife. After his death in 1544 she remarried;
she died before 1564. Both drawing and miniature are
probably datable to c.1540.

89 *Lady called 'Catherine Howard'*
WINDSOR CASTLE, Royal Collection.
Tempera on vellum applied to a playing card
6·3 cm. (diameter).

From the 1840s this miniature has been described as a
portrait of Queen Catherine Howard, but there is no
authentic likeness of Henry VIII's fifth consort. There
is another version of this miniature in the collection of
the Duke of Buccleuch.

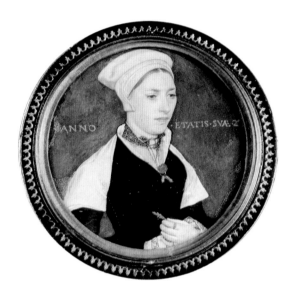

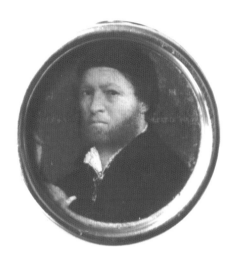

90 *Mrs Pemberton*
LONDON, Victoria and Albert Museum.
Watercolour on a playing card 5·4 cm. (diameter).

This miniature is set as a locket in an enamelled gold
frame which bears on the reverse the arms of the Sago
di Lago family quartered with those of Pemberton.
The woman represented is probably, therefore,
Margaret Pemberton (d.1576), daughter of Richard
Throgmorton and wife of Robert Pemberton, whose
paternal grandmother was the last heir of the Sago di
Lago family.

91 *Self-portrait*
DRUMLANRIG CASTLE, DUMFRIESSHIRE, collection of
the Duke of Buccleuch. 1543.
Watercolour on card 3·7 cm. (diameter).

This is one of four versions of a miniature self-
portrait of Holbein, three of which are inscribed with
the sitter's age and the date of his death, 1543. In each
of these the artist is shown in the act of painting
himself.

92 *Margaret Roper*
NEW YORK, Metropolitan Museum of Art
(Rogers fund). 1536–40?
Watercolour on card 4·5 cm. (diameter).

93 *William Roper*
NEW YORK, Metropolitan Museum of Art
(Rogers fund). 1536–40?
Watercolour on card 4·5 cm. (diameter).

Margaret, the eldest and best-loved of Thomas More's
children, married William Roper, a longstanding
member of More's household, in 1521. At the time she
was sixteen and he was in his twenties; this pair of
miniatures show the sitters about seventeen years later,
a few years after More's death. It is not possible to
arrive at a precise date owing to the conflicting
evidence provided by the sitter's ages given on these
miniatures and elsewhere. Roper came from a wealthy
Kentish family and like Sir John and Sir Thomas More
was a member of Lincoln's Inn. In around 1518 he
entered More's household and remained 'xvj yeares
and more in house conversant with him', despite his
early adoption of the Lutheran faith. Margaret Roper,
a highly intelligent and devout woman, predeceased
her husband by over thirty years and was the mother
of five children. This pair of miniatures is tentatively
attributed to Holbein by most scholars, but the hand
seems slightly different to that seen in the artist's other
miniatures (Plates 86–91).

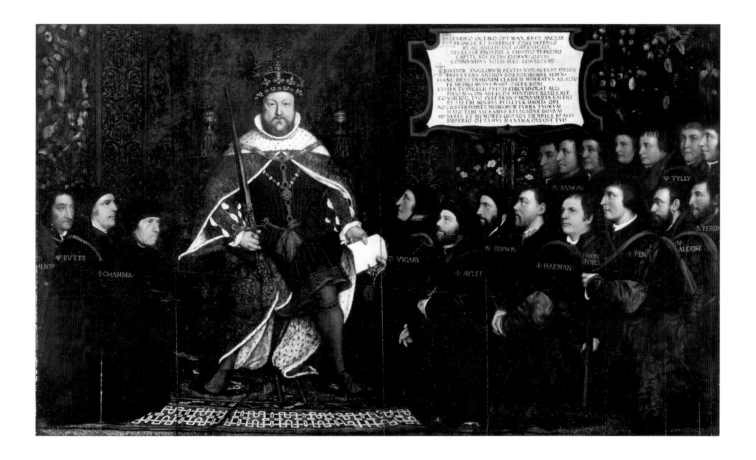

94 *King Henry VIII Granting the Charter to the Barber-Surgeon's Company*
LONDON, Barber-Surgeon's Hall, Worshipful Company of Barbers.
Oil and tempera on canvas 180·3 x 312·4 cm.

This painting was commissioned in 1541 following the unification of the barbers' and surgeons' guilds; the president of the newly-formed body is seen taking the charter from the King, who is raised above the ranks of barbers and surgeons. Two of the latter were portrayed by Holbein in separate portraits, *John Chambers* (Vienna, Kunsthistorisches Museum) and *Sir William Butts* (Boston, Isabella Stewart Gardner Museum). This rather unsatisfactory painting was apparently left unfinished by Holbein at his death and was therefore completed by members of his studio. Another version of the composition belongs to the Royal College of Surgeons, London, and X-rays suggest that it is Holbein's original cartoon covered by layers of later paint. The King appears in this composition almost as an icon, untouchable and raised above the other participants in the scene; in addition he is painted on a slightly larger scale.

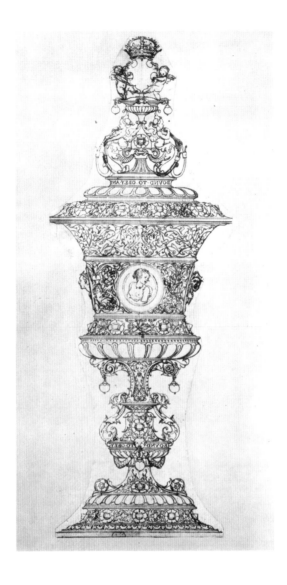

95 *Design For Queen Jane Seymour's Cup*
LONDON, British Museum, Department of Prints and
Drawings. 1536–37.
Pen and ink and wash 37·3 x 14·3 cm.

The abundance of love-knots linking the initials 'H'
and 'I' and the many appearances of Jane Seymour's
motto, 'Bound to Obey and Serve', prove beyond
doubt that this design was intended for a cup closely
connected to Henry VIII and his third consort. The
actual piece was described as in the Royal Collection in
1625 when King Charles I sent Buckingham to

Holland to sell it, together with various other treasures
of a similar nature. 'Item a faire standing Cupp of
Goulde, garnished about the cover with eleauen
Dyamonds, and two poynted Dyamonds about the
Cupp, seauenteene Table Dyamonds and one Pearle
Pendant uppon the Cupp, with theis words: BOUND
TO OBEY AND SERVE and H and I knitt
together; in the Topp of the Cover the Queenes
Armes and Queene Janes Armes houlden by twoe
Boyes under a Crowne Imperiall, weighing Threescore
and five ounces and a half.' The right side of the
design was completed by a later hand.

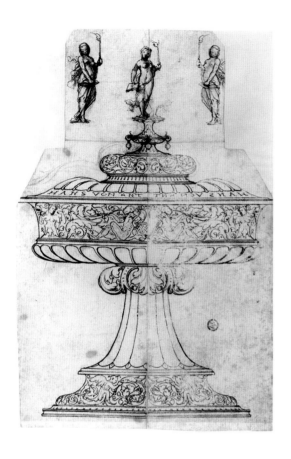

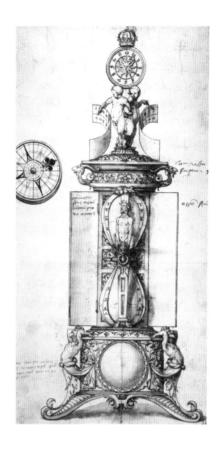

96 *Design for Hans of Antwerp's Cup*
BASEL, Offentliche Kunstsammlung,
Kupferstichkabinett.
Pen and ink with wash and black chalk 25·1 x 16 cm.

Holbein only drew the left side of this design; the right
side is a counter-proof. Around the edges of the lid of
this cup is inscribed the name of Hans of Antwerp
who was a close friend of Holbein (Plate 54). At the
artist's death Hans of Antwerp acted as executor of
the will, which reveals that Holbein had some debts
outstanding with Hans.

97 *Design for Sir Anthony Denny's Clock*
LONDON, British Museum, Department of Prints and
Drawings. 1543.
Pen and wash 41·1 x 21·3 cm. Inscribed with directions
by the artist and by Denny: Strena facta pro anthony
deny camerario regio quod in initio novi anni 1544
regi dedit.

According to the inscription, the clock made from this
design was presented by Denny, at the time
Chamberlain to the Household, to King Henry VIII as
a New Year's gift in 1544. Holbein's design is for an
hour-glass enclosed within an elaborately decorated
case, which is itself surmounted by *putti* holding
curved strips, which serve as sundials, and supporting a
clock; the whole structure is surmounted by a crown.
The figures of terms and the decorative language used
in this drawing are typical of Mannerist designs made
throughout Europe, but especially in Germany, around
the middle of the sixteenth century.

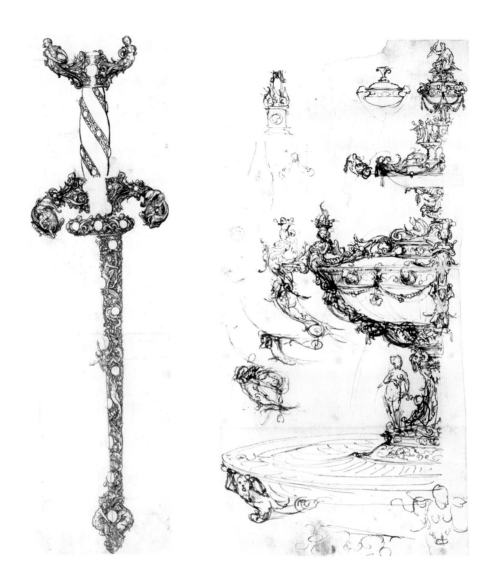

98 *Design for a Parade Dagger*
LONDON, British Museum, Department of Prints
and Drawings.
Pen and ink and wash 45·4 x 12·4 cm.

This very ornate design must surely have been
intended for a royal commission. The dagger was
evidently to be studded with jewels, in the areas which
Holbein left blank.

99 *Design for a Centrepiece*
BASEL, Offentliche Kunstsammlung,
Kupferstichkabinett.
Pen and ink 17·4 x 40 cm.

This design, from a group of studies for objects all
apparently destined for the King, appears to have been
for an elaborate table decoration, with three
superimposed basins and numerous satyrs and classical
scenes, surmounted by the figure of Jupiter
brandishing a thunderbolt. It is among Holbein's most
ornate designs for the decorative arts.

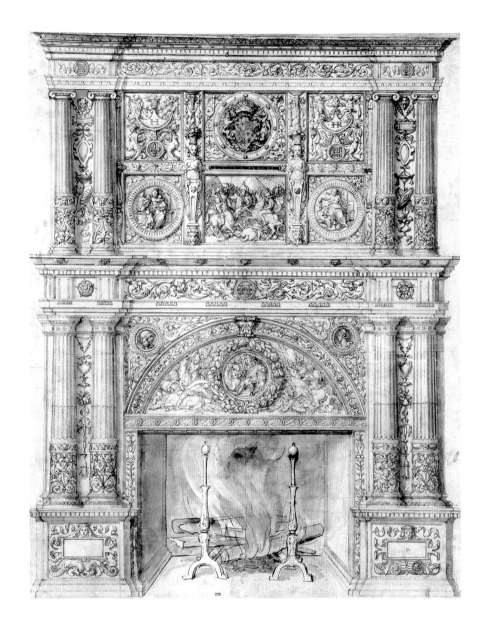

100 *Design for a Chimneypiece*
LONDON, British Museum, Department of Prints and
Drawings. 1540.
Pen with coloured washes 54 x 42·7 cm.

This elaborate design was probably intended for
Bridewell Palace; it is rich in royal and Tudor emblems
and complex symbolism. In the different divisions
formed by the columns, friezes and terms there are
two scenes of combat. This is one of the few
surviving sheets of designs by Holbein for items of
internal decoration, as opposed to mural paintings.

101 *'Scaevola and Porsena' Title-page*
LONDON, British Library. 1516.
Woodcut 18·3 x 12 cm. Signed with monogram.

This title-page was first used in Gazaeus Aeneas's *De immortalitate animae*, published by Froben (Plate 12) in Basel in 1516, but was re-used two years later for Thomas More's *Epigrammata* and Erasmus's *Encomium Matrimonii*, both also published by Froben, as well as elsewhere. The lower part of the page shows the story of Gaius Mucius, a young Roman nobleman who tried to rid his country of the Etruscans, led by their king, Lars Porsena. He entered the king's tent, shown

bottom right, but mistakenly stabbed Porsena's secretary rather than Porsena himself. Gaius Mucius was promptly arrested and condemned to death, but he so impressed his captors by his bravery when he thrust his right hand into a fire in the Etruscan camp that he was freed. He thereafter received the title 'Scaevola', 'the left-handed'. At this stage of his career Holbein simply provided the printer with his designs, which were then translated onto wood and metal blocks by one of the printer's craftsmen; the result is crude when compared with the later designs cut by Hans Lutzelberger (Plates 102, 103 and 105–108).

102 *Illustration to the Opening Page of St Matthew's Gospel*
LONDON, British Library. 1523.
Woodcut 8·2 x 6·6 cm.

This exquisite vignette, first published in Adam Petri's
New Testament (Christmond, 1522), was among the first
of Holbein's designs to be cut on the wood-block by
Hans Lutzelberger. From this point, Holbein actually
sketched his design for a woodcut onto the block
before handing it over to Lutzelberger to cut it. The
quality of the woodcuts made by Lutzelberger is
superb.

103 *'Cleopatra' Title-page*
LONDON, British Museum,
Department of Prints and Drawings. 1526.
Woodcut 23·7 x 16 cm.

This title-page, cut by Lutzelberger, was first used in
Erasmus's *Divi Hilarii Pictavorum Episcopi Lucubrationes*
published by Froben in Basel in 1523. It was frequently
used in later books, and this plate is taken from the
1526 edition of Erasmus's *Christiani Matrimonii
Institutio*. It is an obvious example of Italian influence
and is therefore typical of Holbein's work in all genre
in the early 1520s. The title page derives its name from
the reclining figure of Cleopatra.

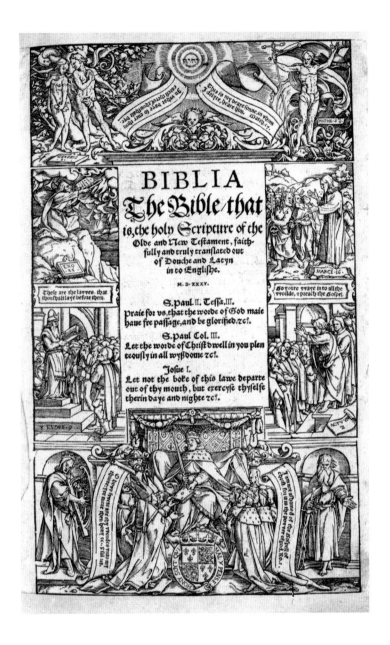

104 *The Coverdale Bible Title-page*
LONDON, British Library. 1535.
Woodcut 31·5 x 18·2 cm.

Holbein's woodcut for the title-page of the Coverdale
Bible, the first complete edition of the Bible in
English, was in four separate blocks. In the lower strip

Henry VIII appears enthroned, sword in hand,
delivering the Word to the lords spiritual while the
lords temporal attend. David and St Paul stand at
either side, representing the Old and New Testaments.
The composition of this scene is, in general terms,
similar to that of *Rehoboam Rebuking the Elders* and
Solomon and the Queen of Sheba (Plates 51 and 85)

105–108 *Proofs from the Dance of Death Series*
LONDON, British Museum, Department of Prints and
Drawings. Published 1538.
Woodcuts 6·5 x 5 cm. (each plate).

The series of *The Dance of Death* woodcuts was first
published in *Les simulacres et historiées faces de la mort*
(Lyon, 1538) but were mostly cut by Lutzelberger in
1523–25. The plates here illustrated show the Count,
the Ploughman, the Last Judgment and the Arms of
Death. The series had an immediate and widespread
popularity.

105 *The Count*

106 *The Ploughman*

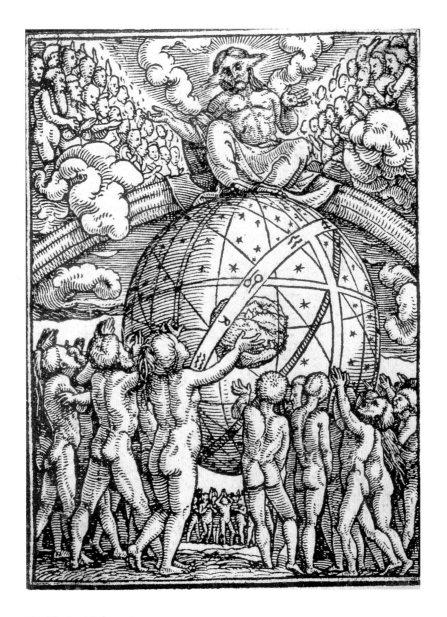

107 *The Last Judgement*

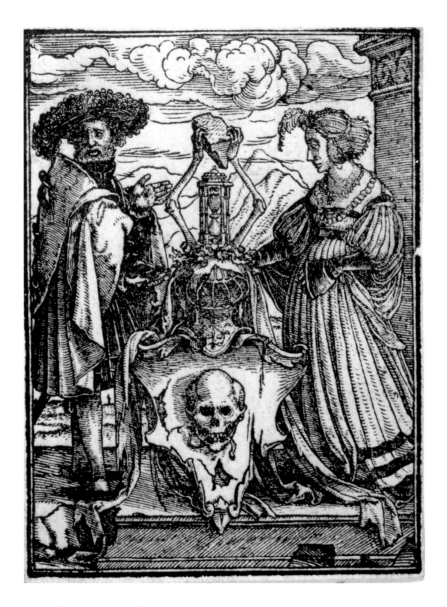

108 *The Arms of Death*

109 and 110 *Plates from 'The Old Testament' Series*
LONDON, British Library. Published 1538.
Woodcuts 6 x 8 cm. (each plate).

(above top)
109 *Judith and the Head of Holofernes*

(above bottom)
110 *Jacob Blessing Ephraim and Manasseh*

These plates first appeared in the *Historiarum veteris instrumenti icones ad vivum expressae*, published in Lyon in 1538, but, as with *The Dance of Death* series (Plates 105–108), they were probably cut over ten years earlier. The Old Testament scenes were issued as a picture book with ninety-one separate plates, rather than as textual illustrations in the usual way.

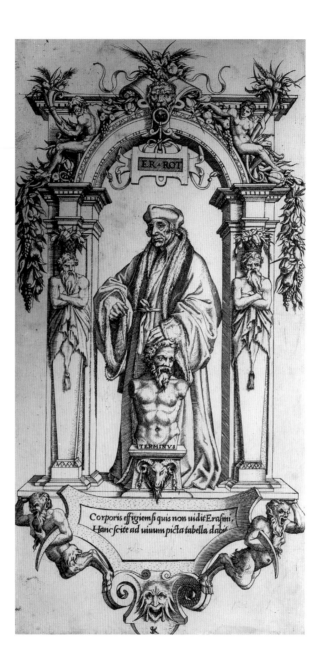

111 *Desiderius Erasmus*
LONDON, British Museum, Department of Prints and
Drawings. 1535.
Woodcut 28·6 x 14·8 cm.

This portrait of *Erasmus* is the last of a long line of
likenesses of him from Holbein's hand. It is unique in
this series in showing him standing full-length.

4/19/06